IMAGES
of America

ARABS
OF CHICAGOLAND

Ray Hanania

ARCADIA

Copyright ©2005 by Ray Hanania
ISBN 0-7385-3417-X

Published by Arcadia Publishing
Charleston SC, Chicago IL, Portsmouth NH, San Francisco CA

Printed in Great Britain

Library of Congress Catalog Card Number: 2005922432

For all general information contact Arcadia Publishing at:
Telephone 843-853-2070
Fax 843-853-0044
E-mail sales@arcadiapublishing.com
For customer service and orders:
Toll-Free 1-888-313-2665

Visit us on the internet at http://www.arcadiapublishing.com

All photographs in this book are courtesy of Ray Hanania, *The Middle Eastern Voice* newspaper, and the *Arab American View* newspaper unless otherwise designated (http://www.hanania.com).

CONTENTS

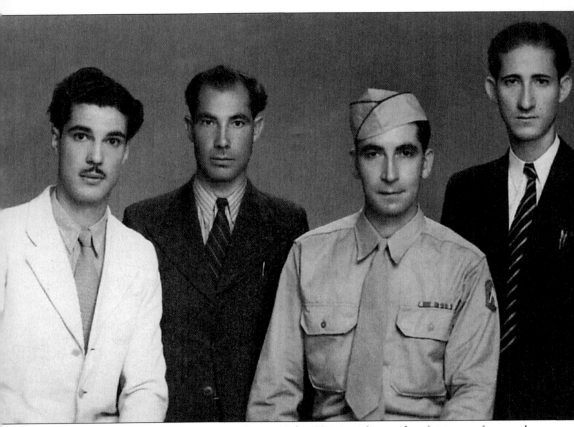

Arab Americans are very patriotic. George John Hanania (in uniform) is one of more than 12,000 Arab Americans who served in the U.S. military during World War II. He is pictured with his brothers, from left, Edward, Khamis, and Farid, in this 1944 photograph, taken while they were together in Jerusalem, Palestine.

INTRODUCTION

The term "Arab American" refers to immigrants who originate from the Arabic-speaking countries in the Middle East. The most notable are Lebanon, Palestine, Jordan, Egypt, Syria, and Iraq. This does not include certain Middle East ethnic groups such as Assyrians, Chaldeans, some Copts, Syriac Orthodox, and Armenians among others, who speak Arabic but do not consider themselves "Arabs." Iranians also are often mistaken for "Arab."

The first Arabs settled in Chicago in the middle of the 19th century on Polk Street near Canal Street, according to records maintained by Hull House. We do not know the exact year. We do know that not long after, a small colony easily assimilated into Chicago's rich ethnic diversity. And soon, more Arab immigrants followed, drawn by the lure of wealth and fortune of several American hosted world's fairs, beginning with Philadelphia's 1876 Centennial Exposition and later, Chicago's 1893 World's Columbian Exposition.

There are three major periods of Arab immigration to Chicago detailed in this book. The first wave of Arabs arrived in the mid-19th century, consisting mostly of Lebanese Christian Arabs fleeing religious persecution in Syria. It also included Arabs, especially Palestinian Muslims, attracted by the allure of wealth from the world's fairs.

The second wave of immigration occurred between the 1930s and 1960s and reflected political change, as nations were formed in the Middle East, and emphasis shifted from the pursuit of wealth to freedom. No single group dominated this period in Chicago's Arab history.

The third and largest wave of immigration to Chicago began after the 1967 Arab-Israeli War and consisted mostly of Christian and Muslim Palestinians who quickly tripled the size of the Arab community. These Palestinians came mainly, but not exclusively, from two West Bank cities located just north of Jerusalem called Beitunia (Muslim) and Ramallah (Christian). Today the Palestinians makeup the largest of the Arabs living in Chicago. They are equally divided between Muslims and Christians with the majority of Christians living on the Northwest Side and the majority of Muslims living on the Southwest Side.

The U.S. Immigration Department did not distinguish between "Syrians" and "Turks" until 1897 or between Syrians and other Asians (classified as "yellow people") until 1899. Thus, all of the early settlers were classified as either Syrians or Turks. Another issue was that most of the Arab countries that exist today were provinces of the Ottoman Empire that ruled the Middle East for more than 500 years through the end of World War I. Although they all spoke Arabic, their cultural traits and even religious practices were distinct from one another.

Two challenges faced in completing this introduction is the absence of any formal record of Arab presence in Chicago. Although Arabs have lived in Chicago from the mid-19th century, they did not have their own news media to record their activities until the late 1960s. Until then, most Arabs in Chicago subscribed to newspapers published in other American cities like New York or others that came from their home countries.

In my research, I was able to tap a variety of sources. Among them include three university dissertations, two completed in 1950 and 1952 by Abdul Jalil Al-Tahir and one in 1977 by Ali Zaghel. Most post-1970s events are based on photographs and interviews from two English-language Arab American newspapers that I published: *The Middle Eastern Voice*, (1975–1977) and *The Arab American View* (1999–2002). During those years, I interviewed and recorded the experiences of dozens of the earliest Arab American settlers who came to Chicago. This book is just the beginning of a badly needed examination of Chicago's Arab Americans.

—Ray Hanania
http://www.hanania.com
rayhanania@aol.com

Nᵒ. 48971

H/1499

GOVERNMENT OF PALESTINE

PROVISIONAL CERTIFICATE
OF
PALESTINIAN NATIONALITY

LAISSEZ—PASSER

Valid until the 31st December, 1926

The bearer GEORGE HANNA HANANIA

A PALESTINIAN

whose photograph is attached and who is described below has been granted this document to enable him to travel abroad and return to Palestine

Date 10th August, 1926

Stanley Pierson

for A/ Controller of Permits

Jerusalem

DESCRIPTION OF BEARER

Place of Birth	Jerusalem
Date of Birth	1905
Domicile	Jerusalem
Height	5'8"
Colour of Eyes	Brown
Colour of Hair	Brown
Special Peculiarities	None
Occupation or Profession	Clerk
Other Particulars	None
	None

J.

Names of Wife and Children under the age of 16 years accompanying

Geo H Hanania

Nᵒ 98

NOTE:— The issue of this laissez passer does not guarantee admission to the United Kingdom or to any British Dominion or Colony or Protectorate, and the holder will be required to comply with the immigration regulations in force in the countries he may wish to enter.

I. & T. 1

حكومة فلسطين
ממשלת פלשתינה (א״י)

شهادة مؤقتة
للجنسية الفلسطينية

תעודה זמנית של הנתינות
הפלשתינאית (א״י)

تذكرة مرور
רשיון לנסיעה

تأر נושא הרשיון

وصف حامل التذكرة

القدس
ירושלים

التاريخ
התאריך

הערה:

Politics have played a major role in how Arab immigration has been mislabeled, ignored, and distorted. One issue is the term "Palestinian." The Arab-Israeli conflict caused many to deny that the term "Palestinian" or that "Palestine" existed. Palestine was controlled by a British mandate through the first half of the 20th century. The mandate government issued this Provisional Certificate of "Palestinian Nationality" to George Hanna (John) Hanania in August 1926, demonstrating beyond any doubt that Palestinians did and do exist. Those denying their existence are politically motivated.

8

One

THE IMPACT OF
THE EXPOSITIONS

The story of Chicago's Arab American community is inextricably linked to the story of Arab immigration to America as a whole. According to official U.S. Immigration Department statistics, the first Arabs to arrive in America were Egyptians and Moroccans in 1838. The first Saudi Arabian immigrants came to the United States in 1861, and the first "Syrian" Arabs in 1866 (Treasury Department, "Tables Showing Arrivals of Alien Passengers and Immigrants in the U.S. from 1820 to 1888," p. 13, 17, 20).

Three Middle East nations participated in the 1876 Centennial Exposition at Philadelphia and contributed to the Arab migration to America. They were Tunis, Egypt, and the Ottoman Empire. Tunis was one of 11 nations that erected its own building and featured Bedouin tents among its displays. The Ottoman Empire, which included Syria, Lebanon, and Palestine, featured a stunning display of merchandise and a Turkish coffee house and bazaar. The Egyptian display was located in the Main Exhibition Building and included items from the Sudan. It featured a reconstructed temple with the inscription: "The Oldest People in the World Sends its Morning Greeting to the Youngest Nation." Among the many items on display were more than 2,000 samples of cotton cloth from Egypt. The Ottoman and Tunisian exhibits emphasized sale items while the Egyptian displays did not (Eric Davis, "Representations of the Middle East at American World Fairs: 1876–1904," Yale University).

Arabs mainly from villages in and around the city of Jerusalem in the Ottoman Province of Palestine brought olive wood artifacts, mother-of-pearl handcrafts, other curios, and olive oil to the fair. The Ottoman Sultan Hamid II had directed his subjects to exhibit their traditional crafts and culture at the American fair. Sporting Western-style clothing and boasting of tales of invention and industry, the returning Arab merchants brought back promises of a great wealth that motivated many of their countrymen to venture to America's shores. The image of America having streets paved in gold was so strong that Lebanese and Palestinian villagers organized "investment groups" of 15 to 20 men, who were dispatched to return to America in the hopes of acquiring wealth to share with other village families. This is sometimes referred to as the "Arabian Gold Rush." Many planned to return with their wealth to their villages, but oftentimes, they never returned except to visit or to bring their families to the United States. A few of these early Arab immigrants trickled to Chicago, and most remained in New York, Detroit, and Ohio. Another impetus for flight was the order by Ottoman Sultan Hamid II for the inscription of Christians and Jews into the military.

The 1893 World's Columbian Exposition marks the beginning of the direct immigration of Arabs to Chicago. It provided Chicagoans with their first real public contact with Arabs, even though a few were living in the city, mostly unnoticed. The man who greeted fair visitors at Cairo Street was a white-bearded Turban-wearing man in balloon pants and robes who was originally introduced to Americans years before by Mark Twain in his travel book *Innocents Abroad*. During a tour of Constantinople (Istanbul), Twain was guided by a man named Moses, whom Twain dubbed "far away Moses." Twain explained that his guide would take him to historical sites but

constantly talk about all kinds of unrelated topics. Twain described him as a humorist.

Another was the make-believe character Gamal El Din El Yahbi. El Yahbi was created by the exposition hosts to help Americans experience the excitement and culture of the Arab World. El Yahbi "owned" an elegant home that was located in the center of the "Street in Cairo," which was one of the main attractions of the 1893 fair, located at the heart of the fair on the popular Midway Plaisance. Other Arabs at the fair included Simon the Syrian, musician; Prince Hamcie, Bedouin sheik who rode Arabian stallions; Syrian women from Palestine; an Egyptian veiled woman; Mohammed, the gypsy dancer many insisted was a woman; copper crafters, who hammered out pots and pans; Mary and Joseph of Bethlehem, with their son Aabeel; the Women of Mount Lebanon in full berqas and embroidered dress; and the Egyptian merchants that sold "Bum Bum" candy for 5¢.

Cairo Street was a composite of many different images a visitor might have seen while visiting Cairo or other Arab cities. It was designed by Max Herz, the official government architect for the Khedive of Egypt, and featured amazing details, such as a Mosque built to the precise dimensions of the Mosque of Abou Bake Mazhar in Cairo. It only lacked the towering minaret where the Muezzin would call the faithful to prayer. The street itself was lined with buildings and storefronts, with their balconies and ornate facades, portals, and mosaic designs, overlooking a fountain and open air market filled with tethered camels and donkeys, which fairgoers could ride. Other features were the Tomb of Thi, a monument to the fifth dynasty (3800 B.C.); the Temple of Luxor of the age of Amenophis III and Rameses II (1800 to 1480 B.C.); mummies (1700–1710 B.C.); and the Tomb of the Sacred Bull, built under Ptolemies (260 B.C.). The Algerians had actually set sail in 1892, one year before the exposition was scheduled to begin, and served as an advance preview for the fair.

The population of "Cairo Street" consisted of 180 "Egyptians, Arabs, Nubians, and Sudanese," and the many-storied home of Gamal El Din El Yahbi, described as a "Mohammedan of the time," was a highlighted feature. (The term "Mohammedan" is an antiquated term considered derogatory today.) There were 61 merchant shops on the street selling souvenirs, all located in the center of the Midway next to the Ferris Wheel.

In his book, *The Devil in the White City*, author Eric Larson wrote: "On March 9, a steamer named Guildhall set sail for New York from Alexandria, Egypt carrying 175 bona-fide residents of Cairo recruited by an entrepreneur named George Pangalos to inhabit his Street in Cairo in the Midway Plaisance. In the Guildhall's holds he stashed twenty donkeys, seven camels, and an assortment of monkeys and deadly snakes."

The most popular Cairo Street attraction was the performance of "Little Egypt," the nickname of Fahreda Mahzar, who danced the "Hootchie Coochie" dance or the danse du ventre (commonly called a belly dance today). She was actually a character role filled by a dozen dancers who performed under the same stage name. One of the more popular of the dancers was Armenian. The dance was performed twice each day, along with sword and candle dancers. There were conjurers, astrologers, fortune tellers, snake charmers, and entertainers of all descriptions. Chicago's Board of Lady Managers filed a formal protest against Mahzar's revealing gyrations. William B. Gray memorialized Cairo Street in his song, "She Never Saw the Streets of Cairo," with these the lyrics: "She never saw the Streets of Cairo, on the Midway she had never strayed / She had never seen a Hootchie Coochie, poor little innocent maid." It was businessman Sol Bloom who created the famous "belly dancing tune" that Fahreda Mahzar danced to and that is most often recognized as the "sinuous emergence of a cobra from a basket." In a preview of Mahzar's dance for the Chicago Press Club, the pianist did not know an appropriate song. Bloom tapped out the impromptu tune, which has since become legendary.

The Columbian Exposition also sparked the first American interest in the Arabian horse, eventually culminating in the formation of the Arabian Horse Club of America, 1908. From the importation of Arabian horses in 1893 for the exposition, a mare, Nejdme, and a stallion, Obeyran, became the number one and two Arabians of the official registry stud book.

Two

THE DOOR OF GOD

FIRST WAVE (1890S THROUGH 1920S)

Although historical maps and documents refer to a small pocket of Arabs who lived near Hull House as the first Arabs who settled in the city, there are only scant references to their presence.

"The Italians, the Russian and Polish Jews, and the Bohemians lead in numbers and importance. The Irish control the polls; while the Germans, although they make up more than a third of Chicago's population, are not very numerous in this neighborhood; and the Scandinavians, who fill north-west Chicago, are a mere handful. Several Chinese in basement laundries, a dozen Arabians, about as many Greeks, a few Syrians and seven Turks engaged in various occupations at the World's Fair, give a cosmopolitan flavor to the region, but are comparatively inconsiderable in interest" (Holbrook). Many of the Syrians were involved in home work enterprises, usually selling handcrafted items and especially embroidery (Watson). In 1935, Hull House was providing care through the Immigrants Protective League to four Iraqis, four Egyptians, eight Syrians, and 44 people identified as Turkish (Immigrants' Protective League). The Hull-House Labor Museum also featured a cultural night on Saturdays in the 1930s where Syrians demonstrated their weaving techniques along with German, Slav, Greek, and Italian immigrants.

The largest immigration of Arabs involved the Lebanese, who began coming to America around 1859 at the outbreak first of skirmishes between Christian and Druze farmers near Beit Miri, and later at Zahlah, which was totally destroyed. The Lebanese settled mainly in Ohio, Michigan, and New York, and many more went to South America. (Later, when Zahlah was rebuilt, one of the main streets was called "Brazil Street.") A few came to Chicago, mostly Maronite Catholic by faith. Every Sunday, they would gather in one of the apartments in a flophouse at Canal and Harrison Streets to conduct church services. Initially, Christian Arab priests visiting Chicago from other cities would conduct services for them. Eventually, in 1905, they secured their own priest, Rev. Msg. S. Roumie, who conducted religious services at a nearby church on Canal Street.

From 18th Street and Michigan Avenue, these Syrian-Lebanese immigrants earned money peddling door-to-door, purchasing the first Arab owned homes just west of the city's downtown, in an area called "Little Zahlah." Little Zahlah was located between Roosevelt Road on the north, 16th Street on the south, California Avenue on the west, and Kedzie Avenue on the east. Family names included Haddad, Malouf (Maloof), Saloum Simon, Jage, Gattas, and Kboony. The heart of the community was at the intersection of Fairfield and 13th Street. They had two social clubs, called The Men's Maronite Club and the Women's Maronite Club, both founded in 1910.

By 1910, three distinct pockets of "Syrian" Arabs were living in Chicago, with the center recognized as being in the area of 18th and Michigan Avenue. In 1911, *The Survey Journal*, in a four-part series called "Syrians in the United States," estimated there were 1,200 "Syrians" living in Chicago, 6,000 in New York . . . and only 56 in Duluth, Minnesota. There were 15 Arab-owned stores in Chicago. The largest American Muslim community in the United States, at the time, was in Providence, Rhode Island. Some 150 Muslim residents, not all Arab, lived in Chicago.

"In Chicago, there are also 3 colonies resembling those of New York in gradation of living, though not in size. The poorest is housed in an uncomfortable region near the railroad tracks, evidently chosen from consideration of rent. This was formerly one of the most disreputable quarters of the city, and it still has the reputation among those who are ignorant that the entrance

11

of Syrians, killing off the saloon trade, has driven away the disreputable inhabitants. (This was the case in 1909. The property has recently been bought by the railroad and the Syrians who lived there were removed to better parts of the city.) The other colonies, like those of New York, are better standing in proportion as they are farther from the center." (*The Survey Journal*, "Syrians in the United States," Vol. 26, No. 14, pp. 492, July 1, 1911.)

On June 24, 1910, the first Christian Arab Church was established in Chicago called St. John the Baptist Melkite Church, 1343 S. Washtenaw Avenue. (Other sources put the addresses at 1247 West 12th Street.) It had the blessing of the archbishop of the Chicago archdiocese. Rev. Msg. S. Roumie became its first pastor. It later relocated to 200 East North Avenue in Hillside. The largest group of parishioners were Christian Lebanese. On April 22, 1918, they founded the Syrian-Lebanese Progressive League located at 1365 S. Fairfield Avenue, in Little Zahlah. In 1922, they founded the Syrian Girls' Sorority.

As early Lebanese settlers migrated west into the neighborhoods of Chicago, another group of Christian and Muslim Arab immigrants began settling in Chicago. These Arabs were mostly Muslim Palestinians from Beitunia, a city located a few miles north of Jerusalem. They continued in the tradition of door-to-door peddling and settled in the 18th and Michigan area, too. Peddling was a difficult profession, but grew in popularity among new immigrants, especially the Arabs. While Christian Arabs attended nearby churches, Muslims held religious services conducted by Sheik Mohammed Yusef, who would travel to Chicago from Detroit.

The Arab peddler was an extension of the Arab merchant in the great souqs (open air markets) of the Middle East. The peddlers who came to America saw their profession as demanding as the work they left behind, except they found more opportunity here, and less back home. Because it was strenuous work and required long hours of walking, carrying a heavy suitcase of merchandise, usually bed spreads, shirts, combs, and brushes, the early Arab peddlers referred to their work as "knocking on (or opening) the door of God" (Yatlah ala Bab Allah, in Arabic).

Most of the peddlers purchased their resale items on consignment from a Palestinian wholesaler some recall only as Khaled Ali near 18th and Michigan. Later, a Lebanese immigrant named Aziz Shaheen operated a small wholesale outlet a few blocks west at 305 W. Adams Street in the 1950s. At night after knocking on doors selling wares from their suitcases, Arab immigrants would congregate at the Kahwa al Ibtisan coffee house at 18th and State Street and two blocks east at the Mecca Restaurant, 1806 S. Michigan Avenue. Arabian food specialties were served at both, and Arab merchants would congregate, find comfort, and share their experiences. The Mecca Restaurant was reportedly originally opened in 1915 (possibly under a different name at that time) by a Palestinian immigrant named Samhan Asad. Descendents said his family moved to Milwaukee in the 1940s. The transition from peddling to small stores began sometime around 1924.

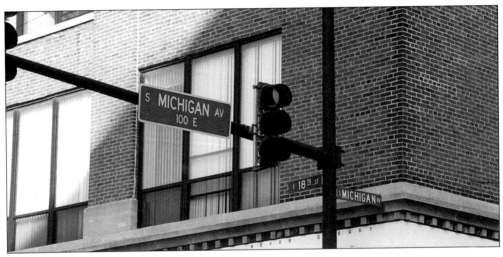

Second Wave (1930s to 1970s)

Arab immigration was steady through the 1920s, but came to a near halt during the Depression. The 1933 Century of Progress Fair attracted some Arabs, but immigration did not really pick up again until the onset of World War II. Most of the 50 Arabs clinging to the Arabic Quarter at 18th and Michigan were Beitunia Palestinians, married men who left families in Palestine to earn riches. Other Lebanese had slowly migrated westward and Palestinians migrated mainly along Michigan Avenue as far south as 59th Street. By the 1940s, Christian Palestinians from Ramallah began to join them.

Americans could not see distinctions in Arab culture and viewed them all as "Syrians" or Arabs. In their book *Chicago Confidential*, authors Jack Lait and Lee Mortimer write about the "Sons of the Prophet," introducing readers to this Middle East warren of the city. Typical of the times, it included racial overtones that dominated American attitudes towards the Arabs.

> "You won't find any camels at 18th and Michigan. Chicago's small Arabic quarter is surrounded by Automobile Row. If you can digest such, there are several native restaurants serving Near Eastern delicacies which you are supposed to eat with your hands. Arabs sell tapestry and rugs, wholesale and retail. Many merchants who say they are Arabs (because business is business) are not. You will find no orgies out of the Arabian Nights here. Chicago's Arabs don't keep harems and if they did you wouldn't care to look twice at their women. They wouldn't be to your taste. The chief past time is drinking thick, black coffee and playing cards."

Chicago was racially divided between blacks and whites with most Arabs living in buffer zones between the two. As the border shifted, Arabs relocated, too, though early Arab immigrants believed African Americans were friendlier. (Arabs had olive skin and black hair, and many whites viewed them as "light-skinned" blacks.) Ironically, the first Muslim Mosque, or Jama as it was termed in Arabic, was founded in the 1940s by African Americans who converted to Islam. It was located at 4448 S. Wabash Avenue.

Both the Christians from Lebanon and the Muslims from Beitunia continued to prosper in Chicago as Arab immigration continued. Muslims from Beitunia had founded the Children of Beitunia Society and reorganized it in 1924 as the Arab Progress Society. The Children of Beitunia Society was re-constituted in 1945. There were many other groups, including the Arab-American Aids Society. All sent money back home, helped new immigrants get settled, donated to the Red Cross during the World Wars, and also contributed money to support the Arab defense of Palestine. Kayyad "Edward" Hassan, a founder of the Arab American Veteran's Association based in suburban Palos Heights, recalled that immigration from Beitunia got a boost in the 1930s when the U.S. embassy in Jerusalem increased the number of travel visas. Beitunians were among the first to secure them in large numbers.

Christian Palestinians from Ramallah, the neighboring city to Beitunia, began arriving in the 1940s and 1950s. In his study, al-Tahir reports there were about 40 Ramallites in Chicago in 1950. By 1952, the Ramallah Palestinians who settled in larger numbers in other cities, had launched a national magazine, *Hathihe Ramallah*, and founded the American Ramallah Federation in Detroit, Michigan, in 1960.

In 1976, Zaghel followed up on al-Tahir's work, and their studies remain the only public records of an Arab presence in Chicago along with the founding in 1975 of *The Middle Eastern Voice* newspaper. Very clannish, the Ramallah and Beitunia Palestinians migrated to different areas of the city, with Muslim Beitunia Arabs settling mainly on Chicago's Southwest Side while Christian Ramallah Arabs settled on Chicago's Northwest Side.

The early Syrian and Lebanese settlers founded the Syrian Club in Chicago and changed its name in 1948 to the Syrian-Lebanese Club, reflecting the independence of Lebanon from Syria. In 1971, they formed the Chicago Chapter of the Phoenician Club, linking to the national Lebanese organization, which was established in 1918. Its members sought to reinforce their

ancient historical and cultural roots rather than their identity as Arabs. Despite their focus, membership was open to all Arabs, including Jordanians and Palestinians. The Phoenician Club of Chicago partnered with television actor Danny Thomas (*Make Room for Daddy*) in launching American Lebanese Syrian Associated Charities (ALSAC), which funded St. Jude's Research Medical facility in Memphis, Tennessee. Mainly because of their early immigration and their Christian religion, which helped them more easily identify with American culture, the Lebanese have achieved success in businesses and in elected office. A large pocket of Lebanese Americans settled in Peoria, Illinois, a two-hour drive south of Chicago. There, they elected a congressman, Ray LaHood, several legislators, including George Shadid, and the longtime mayor of Peoria, Jim Maloof.

In 1959, the predominantly Lebanese Maronite Catholics established their own church, Our Lady of Lebanon, and purchased a building in the western suburb of Hillside several years later. Fr. Roumie was succeeded by Rev. Riashi, who was a pastor until his death in 1962. He was succeeded by Rev. Denisoff and later Fr. Cyril Haddad. The Orthodox Christians, mainly Palestinian and Jordanian and some Lebanese, founded St. George Church at 1125 N. Humphrey in Oak Park, in the 1960s.

From 18th and Michigan, Beitunia Palestinians and some Christian families migrated south and southwest, first settling at 45th and Ashland Avenue where an Arab restaurant called Shahrazad was established. A larger colony formed along 63rd Street between Western and Kedzie Avenues in the 1970s. By the 1990s, this migration grew in numbers and continued southwest into Burbank, Oak Lawn, Bridgeview, and Orland Park. An Arab community center was established at 55th and Fairfield. When it closed, another opened at 63rd Street near Kedzie. The first Arab Mosque was announced in the spring of 1956, resulting in a newspaper article that year in the *Chicago Tribune* entitled "Moslems Buy Building for Use as Mosque."

"The Mosque Foundation of Chicago has purchased a home of its own which will be the first mosque in Chicago, according to Hassan Haleem, secretary-treasurer of the foundation.

He said the building, a former church at 6500 [South] Stewart Avenue, was purchased from the South Side association for $100,000. . . . [The Mosque will service] many families from Arabian countries, the majority from Palestine, during the last few years. The society was formed two years ago by 10 or 15 families.

"Haleem said there were about 100 Islamic families on the south and southwest side, including more than 200 children. Most of them live between 63rd and 79th Streets, and Stony Island and Halsted Street.

"Islamic Creed

"To continue their customs, to follow and practice their religion, and to instill these habits together with the Arabic language in the minds of their children, they felt a great need for forming a society," Haleem said. The Society President is Abdallah Shoukry.

"Their religion has this creed: 'There is no God but Allah and Mohammad is his Messenger.'"

Hassan Haleem carried this newspaper clip in his wallet and gave it to the author during a 1976 interview.

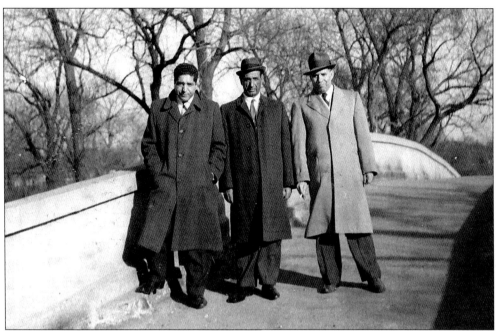

(above) Mohamed Mansour (from right), his father-in-law Maaz Hassan, and a friend pose on the bridge at Sherman Park in 1962. Mohamed's father Husni Mansour (on the cover of this book) immigrated to Chicago in 1941 through the Arab community at 18th and Michigan. Mohamed's wife Nafeeza joined him in 1960, and they lived in a home at 55th and Elizabeth near Sherman Park, west of Hyde Park, in 1970. The family later moved to the Ashburn neighborhood near 84th and Lawndale in 1991 and then to the Southwest suburb of Oak Lawn. His son Mahmoud "Mac" Mansour is a Chicago firefighter and worked briefly with his brother Jack in real estate in the Oak Lawn area. (below) Mac Mansour is on the left, and Jack Mansour is on the right.

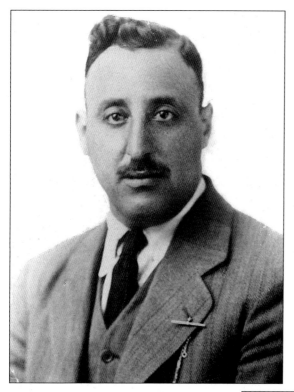

Arab merchants still had to learn the customs, and they learned quickly that they had to satisfy the demands of the local politicians. One of the first Muslim Palestinian families to arrive in Chicago was the Haleem family. Four brothers, Ahmad, Hassan, Mohammed, and Abed, were the sons of Mahmoud and Sophia Haleem. They had one sister, Fatima. The Haleem family came from Beitunia. Pictured left is Ahmad Haleem, who left Palestine in 1914 and immigrated to Chicago. Ahmad served in the U.S. military during World War I and was honorably discharged in 1917. Ahmad returned to Palestine to help build a Palestinian nation in 1919 and died in 1983 at the age of 90. Ahmad produced olive oil and baked goods for the farming village of Beitunia, which is located next to Ramallah several miles north of Jerusalem in what is today commonly referred to as the West Bank.

(*right*) Ahmad's brothers are (from left) Hassan, Mohamed, and Abed Haleem, in this picture taken in 1970. They followed in the footsteps of Ahmad Haleem after being moved by his stories of American life and immigrated to Chicago in the 1920s. Hassan and Abed each owned clothing stores at 39th and Cottage Grove in the 1930s through the mid 1950s. They continued to operate clothing stores on the South Side at different locations through the 1950s. Abdul Rahman Haleem eventually retired in the late 1960s and went back to Palestine where he spent the rest of his life. He died at the age of 72 in 1978 while traveling back from his pilgrimage to Mecca. He was survived by his two sons Waheed and Mofeed Haleem and daughter Samiha. Mohamed came to America in the early 1920s. He also operated a small clothing store on the southeast side of Chicago from the early 1940s until the early 1960s. He died at the age of 77 in 1976. He was survived by his wife Fatima, daughter Sophia and stepdaughter Dora.

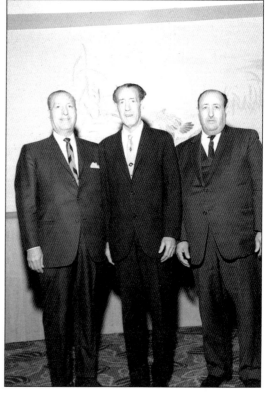

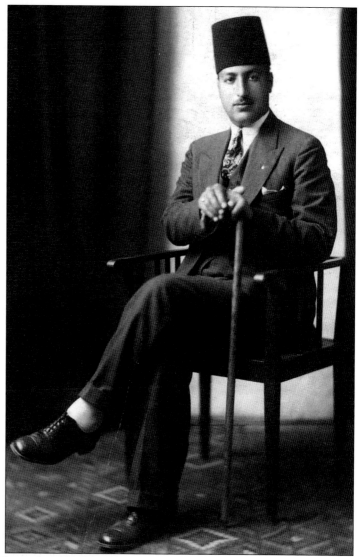

Hassan Haleem became active in the Palestinian Arab community and joined other community leaders in raising money to build a mosque, or an Islamic house of worship. Hassan Haleem is often looked at as the patriarch of the Palestinian American community in Chicago and was active in the early days of building the first Arab mosque.

"We had to get permits to peddle merchandise from our suitcases," Haleem recalled during an interview the author did with him at his Oak Lawn home in 1976. "We would meet with the aldermen, 'Bathhouse' John Coughlin and Hinky Dink Kenna. We had to pay them the registration fee, and a small fee for them, personally. Then, we could peddle our wares on the street. The permit would be fixed to the suitcase."

Hassan Haleem and other Arabs, Christian and Muslim, Palestinian and Lebanese, often worked together in the early days to help newly arriving immigrants from the Middle East.

Oftentimes, the Christians and Muslims would share a location and invite a Christian Orthodox Priest and a Muslim Imam to provide religious services to the members of the community. They also provided classrooms on Saturday and Sunday where the children of both Arab communities could learn Arabic and study Arabian history. Hassan died in 1996 at the age of 92. He was survived by his wife, Mary and his five sons, Adell, Fouad, Reyad, Jameil, and Nehad.

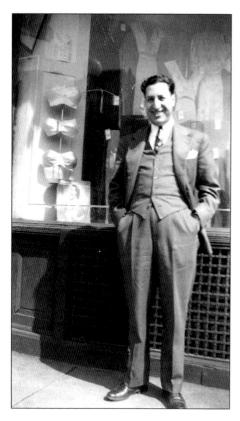

This photograph of Hassan Haleem was taken in 1943 in front of his store at 39th and Cottage Grove.

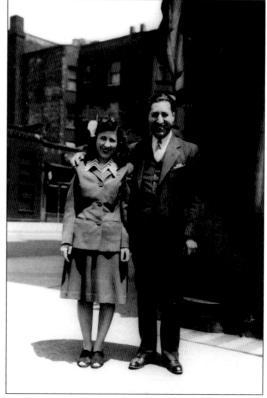

This picture of Hassan Haleem was taken in 1944 in Chicago with his wife, Mary. (Photographs of the Haleem family courtesy of Neil Haleem.)

THIRD WAVE (1970S TO PRESENT)

There were already several other store front mosques and Arabian schools. One was located at 79th and Clyde Avenue in South Shore. It served as both a Mosque on Fridays and as a school teaching the Arabic language to young Arab children on Saturdays. Many Christian families sent their children there to study Arabic, too. One of the parishioners of the al-Salam Mosque was Yusef Diab, who arrived in the early 1960s and taught Arabic to Christian and Muslim children on Saturdays at the South Side class.

Muslim Palestinian surnames of the earliest settlers included Haleem, Judeh, Zaghlool, Sousif, Salah, Shaloot, Khairallah, Maali, al-Din, Diab, Zayed, and Suleiman.

The Ramallah Palestinians, along with several Jordanian families who immigrated around that time, established St. George Orthodox Church at 1125 N. Humphrey, Oak Park. Originally founded in the 1960s, St. George drew parishioners from as far away as Indiana. In the late 1980s, the church relocated to its current church property at 1220 S. 60th Court in Cicero, Illinois.

In 1976, Zaghel obtained the mailing lists used by the various community organizations to plan their weddings and haflis (parties), and estimated that there were more than 15,000 Arabs in Chicago. Yet the list was incomplete because not every Arabian ethnic group had an organization or kept a mailing list.

According to Zaghel, there were 8,000 Palestinians in Chicago in 1976, with 6,500 originating from Beitunia. (His data showed that there were only 250 Christian Palestinians from Ramallah and 1,800 Muslim Palestinians from Beitunia in Chicago in 1965.) Zaghel documented 2,500 Syrian/Lebanese Arabs (almost entirely Christian), 2,000 Coptic Christian Arabs who began arriving from Egypt in 1955, about 750 Jordanian Arabs (mostly Christian), and 500 Iraqi Arabs (not Assyrian) who began arriving in 1963. His study identified 1,000 Arabs mainly from Yemen and other Gulf States. (The year 1965 is important because at that time, the United States eased its immigration restrictions imposed following the war, in which five of seven preference immigration categories favored qualified relatives of U.S. citizens or permanent residents.)

Today, as a result of increased immigration since 1976, it is estimated that the Arab American community actually numbers around 250,000 in the six county region around Chicago, although because the U.S. Census has declined repeated attempts to include an "Arab" category, the precise number is not known. Of that, about 135,000 Arab Americans live in the city of Chicago, though this number continues to decline as more and more Arab families follow the primary migration path to communities in the Southwest suburbs, with smatterings relocating to North and Northwest suburban areas. There are about 75,000 to 85,000 Arab Americans living in suburban Cook County around Chicago. The largest concentration of Arabs live in the Southwest suburbs (55,000–60,000), and the remainder (20,000–25,000) live scattered in the western and Northwest suburbs with no real concentration in any one area. Even these numbers are estimates and are based upon numerous interviews with community leaders.

Many early Arabs are buried at Oak Woods Cemetery in Chicago. In the 1970s, the Arab community turned to cemetery plots in Evergreen Park.

Other major waves of immigrants to Chicago included Egyptians who were mostly Muslim and who settled in Chicago in measurable numbers in 1955. They were driven mainly by dissatisfaction with the regime of President Gamal Abdul Nasser. Most were professionals, including doctors, lawyers, and professors, and they came with their families. In 1960, a group of 15 immigrated together to complete university graduate work. The major immigration of Egyptians began after 1967, and about 1,500 Egyptian Americans including Coptic Christians settled in Chicago. Most were attracted by economic opportunity and because of religious reasons. Many settled around Sheridan Road and North Kenmore, where a Coptic Church was established.

Iraqi immigration began in significant numbers in 1963, mainly as a result of political

instability in Baghdad. They were mostly Muslim and professionals. Chicago also has a large population of non-Arab immigrants from Iraq, who are called Assyrians and number more than 100,000.

In the 1950s, the Jordanian immigrants originated predominantly from four cities in Jordan; Madaba, es-Salt, Irbid, and El-Fuheis. They were mostly Christian, and they originally settled around Logan Square on the city's Northwest Side among the Ramallah Palestinians. A popular gathering point of Jordanian activity was the St. Charles Restaurant at nearby Montrose Avenue and Lincoln Avenue, which was owned by a Jordanian Christian from Madaba. The restaurant was opened sometime in the 1950s. In the late 1970s, they launched a newspaper called the *Voice of Jordan*, which continued through the next three decades and was published by Ihsan Sweiss, who became the honorary Jordanian consulate general in 2001.

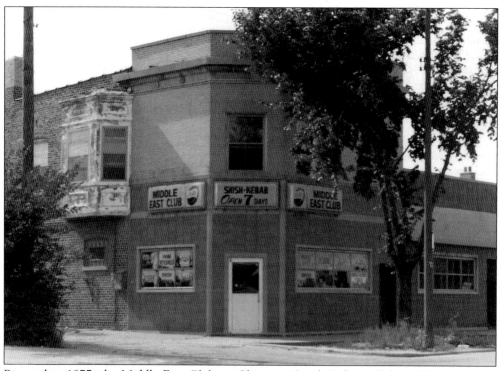

Pictured in 1977, the Middle East Club on Chicago's South Side at 55th and Damen was a popular restaurant and coffee shop where Arab men would gather to play cards and "Shash Bash" (backgammon).

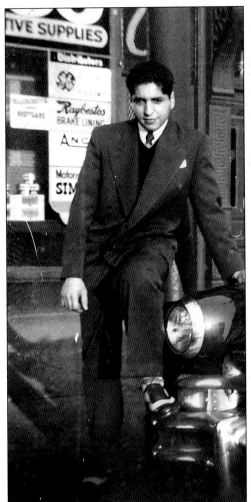

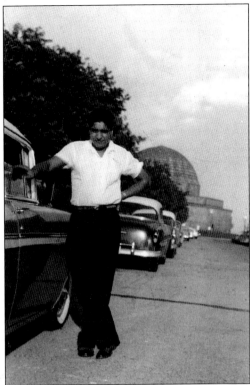

(*above left*) Mohamed Mansour stands with pride next to his new Imperial in 1953 at 18th and Michigan Avenue. (*above right*) Mohamed Mansour (father of Jack and Mahmound "Mac" Mansour), poses in 1951 with the Adler Planetarium in the background. Mohamed's father is featured on the book cover. (*right*) Mohamed Mansour's wife, Nafeeza, poses with her father Maaz Hassan in 1962 in the garden of their home at 55th and Elizabeth in Chicago. (All photographs of Mansour family courtesy of Mahmoud "Mac" Mansour.)

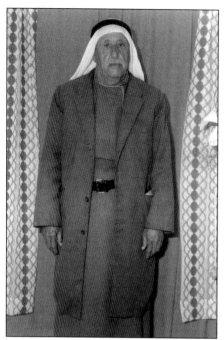

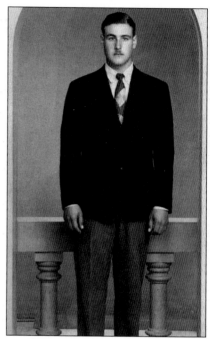

(*above left*) Ahmad Haleem is seen here in Palestine, 1975. (*above right*) Ahmad's son Yousif "Joe" Haleem came to America in 1956. He was a pretzel maker for Nabisco for 26 years. He died at the age of 60 in 1986 shortly after his retirement. He was survived by his wife Nadra, his sons, Ahmad and Neil, and daughter Naela. (below) The Haleem family is pictured here: (back row from left) wife Maysoon, Neil (son of Yousif Haleem), and their daughter Yasmeen, who was celebrating her eighth grade graduation in this photograph taken June 1, 2004; (front row from left) sons Abraham and Adam. (All Haleem photographs courtesy of Neil Haleem.)

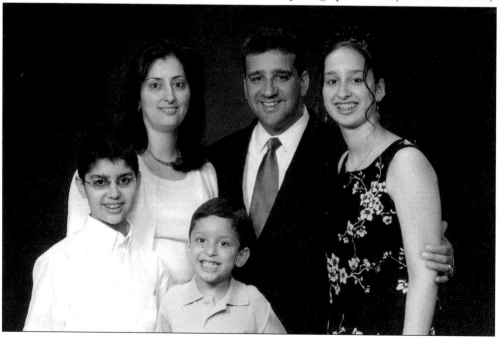

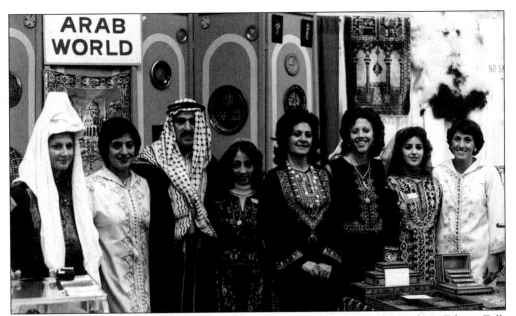

Arab Americans organized the Arab World display at Mayor Richard J. Daley's Ethnic Folk Festival that was held at Navy Pier. This photograph was taken on October 31, 1976. Pictured are writers Leila Diab (second from left) and Mimi Kateeb (fourth from left), the author's mother Georgette Hanania, Grace Suzanne Hanania, and Fadwa Hasan (far right). Leila Diab went on to become a journalist. Mimi Kateeb worked on the *Voice of Palestine Radio* and was a writer for *The Middle Eastern Voice*. Fadwa Hasan became a teacher with the Chicago Board of Education. This display was one of three reflecting Arab World culture at the festival. A second display was set up by the Egyptian American community and another by the Assyrian American Community. The items on display were from the homes of the organizers. The display itself was put together by the Arab American Congress for Palestine and cosponsored by the *Voice of Palestine Radio* program, which provided news and information to the Chicagoland Arab American community for many years. It's not surprising that so many of the volunteers at this and other events were women. Like the women of the Middle East, Arab women are among the leaders in getting the work done. Their leadership has strengthened the Chicago Arab American community, and this book is dedicated to them.

Pictured at the Arab exhibit at the Ethnic Folk Festival is Palestinian activist Said Halawa.

23

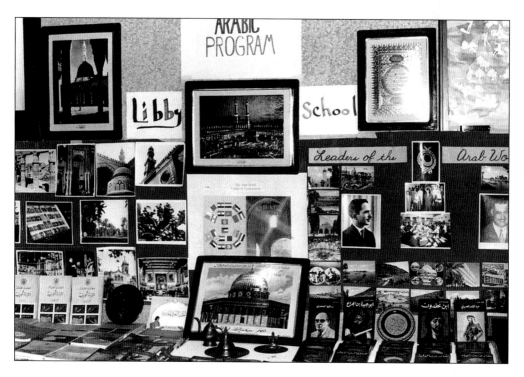

(*above*) Pictured here is one of the Arabic cultural exhibits at the Ethnic Folk Festival at Navy Pier in 1976. (*below*) An exhibit set up by members of Chicago's Egyptian American and Coptic Orthodox Christian community also at the Ethnic Folk Fair that same year.

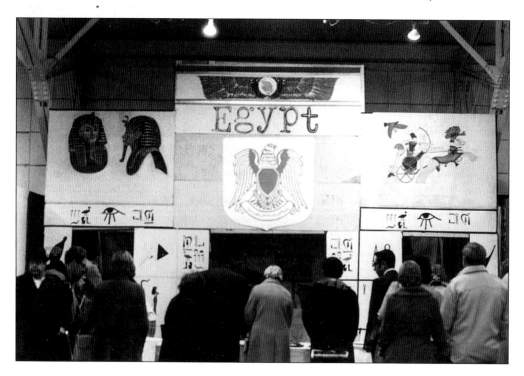

Three
SELECTED PROFILES

Piecing together the stories of Arab American immigration to Chicago is a difficult challenge. Over the years, a few stories have been recorded but never published, and others remained in the fading memories of children, relatives, and friends. The profiles in this selection were chosen from that small pool based on their experiences, although every effort was made to include a cross-section of Chicago's Arab community. Included are individuals who are Lebanese, Palestinian, Jordanian, Christian, and Muslim. No real record of their entry exists. No one documented their experiences. Many stories, especially those predating the 1970s, have been lost to history. And yet those lost stories are the very proof of a community's love for this country. They represent the experience of Arab Americans outside of today's skewered political atmosphere driven by the Middle East conflicts and the terrorism of September 11th. Those early pioneers represent the true essence of the contribution Arab immigrants sought to make to this great country.

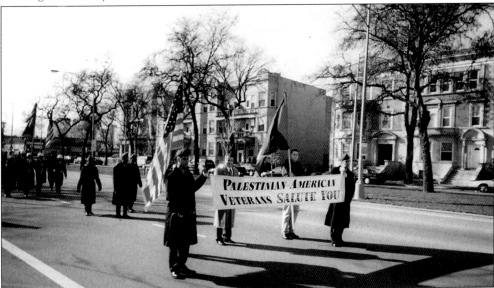

Kayyad "Edward" Hassan, president of the Beitunia American Club and a U.S. military veteran, leads Arab American participation in a South Side Veterans' Day Parade. About a dozen Arab Americans who served in the U.S. military participated in the parade demonstrating Arab support of the United States. Arab Americans have played a major role in defending this country at times of war and conflict and are proud of their patriotic history.

Joseph R. Shaker

(*left*) Joseph Richard Shaker is the son of Isaac and Sophia Shaker, immigrants who came to the United States from Lebanon in 1900. Born in 1887, Isaac Shaker Awad arrived alone at Ellis Island at the age of 13. The badge on his sweater represented him as "Isaac son of Shaker" (Isaac ib'n Shakir), as Shakir was the first name of his father, and his name became Isaac Shaker. Isaac's destination was Youngstown, Ohio, where his family had arranged for his support by Lahood Yezbek, who had assisted others from the Lebanese town of Toula. At Lahood's store, Isaac cleaned, assisted, and learned the retail industry, which ultimately became his livelihood. Isaac arranged to bring his brothers, Akel and Joe, to Ohio from Lebanon, and together they opened a five and dime store. In Niles, Ohio, Isaac eventually opened the Shaker Store—the tallest building in the area.

Joseph's mother Sophia Hikel arrived in the United States at the age of seven with Alice in the hold of a ship; Uncle Jim George arranged for them to come. During the trip, they saw spaghetti and thought it was worms. They first lived with their grandmother in Wellesville, Ohio, until Sophia became 16. Isaac would take the streetcar to meet her, and they were married in Mount Carmel Church in Niles. The reception was held on the third floor of the Shaker building.

The Shaker sons joined the military during World War II. Mitchell served in the navy, Simon the army, and Joseph the air force. Because two sons were already serving overseas, Joseph was stationed domestically in Mississippi. After completion of his military obligation, Joseph R. Shaker moved to Chicago where he met and married Helen (Abraham) also of Lebanese descent. They celebrated their 57th wedding anniversary in 2005.

Joseph R. Shaker founded the Shaker Advertising Agency in Oak Park in 1951. He had a vision for how to revolutionize recruitment advertising and partnered with clients in their recruitment efforts. These relationships and the family heritage compose the story of Shaker Recruitment Advertising & Communications. Shaker began by providing the most innovative recruitment advertising solutions available. Through hard work and dedication, the agency earned a reputation for delivering the best service around. Shaker has collaborated with thousands of clients, and today, they are the world's largest privately owned recruitment advertising and communications firm. They have branches and satellite offices in Tampa, East Brunswick (New Jersey), and Boston. The company is today headed by Joseph R. Shaker's son, Joseph G. Shaker (*right*). Shaker Advertising employs more than 175 people and projects annual sales of $85 million. (Photographs courtesy of Joseph G. Shaker.)

GEORGE MOHAMMED

(*right*) Azzat Mohammed (back row, center), Aziz Saba (back row, right), and Mohammed Abdelatif (front) came to the United States in 1910, settling in Pittsburgh. Mohammed and Abdelatif (Muslim) and Saba (Christian) were all from the Palestinian village of Ein Arik. In 1912, Azzat Mohammed married Hafiza Ibrahim Hasan Abdullah al-Curt (pictured in the back row on the left), who was from Beitunia. This picture was taken in 1929. Like most Arabs, Azzat married his wife but left her in the old country for 15 years while he worked in the United States. During that time, Azzat was drafted into the U.S. Army during World War I.

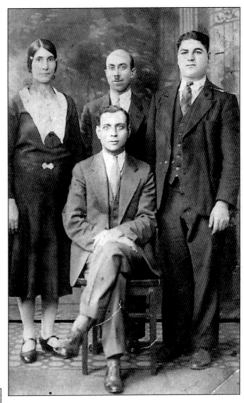

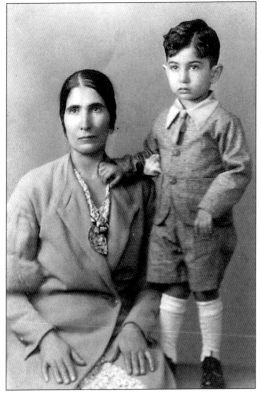

(*left*) Hafiza is pictured here with her son, George Mohammed (Azzat) in Pittsburgh in 1935. George is about three years old in this photograph.

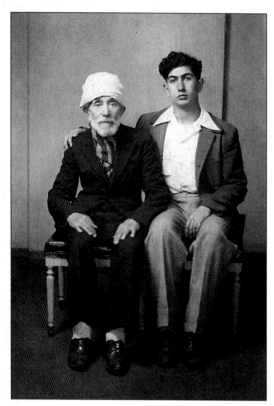

Hafiza and her son moved to Chicago around 1945–46 after Azzat died to live near Hafiza's relatives from Beitunia. Pictured is George Mohammed (right) with a boarder, Mohammed Amun. Amun, from Morocco, was a traveling salesman who would go from city to city to participate in fairs and expositions selling Middle East and Holy Land merchandise. While in Chicago, Amun stayed with the Mohammed family. Amun is wearing a typical Moroccan necktie, which Americans adopted years earlier from the Moroccan fashion. The Mohammeds lived at 3980 S. Drexel before moving further south and becoming neighbors of the Haleem family and sharing a two flat with the Zayid family. (Photograph courtesy of the Mohammed Family.)

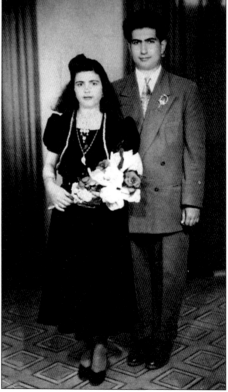

George Mohammed is pictured here in 1954 with his new bride, Yamneh (Amneh) Ali Ghannem. Her father was a teacher at Ein Arik and also the regional Imam. Today, the family and their children live in the Southwest Side of Chicago and Southwest suburbs of Orland Park. George's daughter Saffiya is a community activist who worked for several years as the director of Ethnic Affairs for Illinois Lt. Gov. Corinne Wood. (Photograph courtesy of the Mohammed Family.)

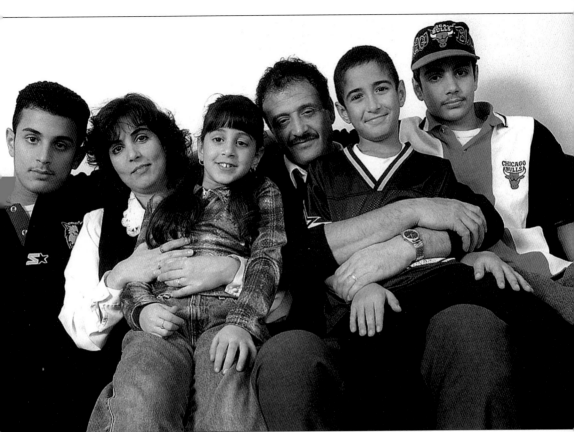

Ali Shillo and his wife Saffiya (Mohammed) Shillo are pictured here. Ali is a teacher at Richard J. Daley College on Chicago's Southwest Side. Saffiya is a longtime Arab American activist who headed the opening of the Chicago Chapter of the Arab American Institute and formerly served as the Chicago Chapter president of the Palestinian American Congress. She served as the director of Ethnic Affairs for Illinois Lt. Gov. Corinne Wood for two years beginning in January 2000. Shillo succeeded Mary Diab, a Greek American who was married to a Palestinian, in the post. And Diab had briefly succeeded Maysoon Deeb, a Republican political strategist who left the post for assignment in Cairo, Egypt. Wood's successor, Patrick Quinn, eliminated the office in 2004, removing one of the only Arab Americans in statewide office. Pictured are Ali and Saffiya and their children Ibrahim, Jinan, Sam, and Adam.

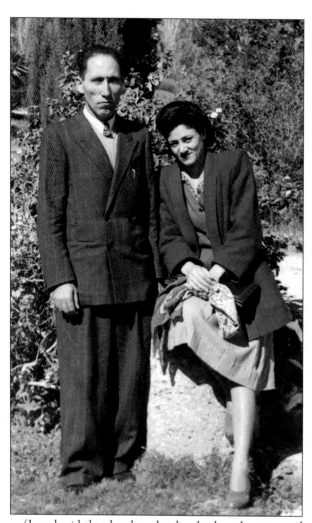

JAMAL KATEEB

Sometime in late 1975 or early 1976, the author participated in an interview with Jamal Kateeb, who described in a tape-recorded conversation (presented to the family in 2004) how he came to America and worked as a peddler. Here is his story:

"It was very difficult to come to Chicago. I will never forget the first day I went out to sell. I knocked at a door, and a lady came out yelling and I did not know what she was saying. I was so scared. It was at Lawndale and Kedzie. I met my brother (Hatem), and he asked me did I do anything? I said 'yes, the lady took everything, but I don't know.'

"My brother said that he didn't think I could stay in the business, and he wanted to give me a couple hundred dollars to get me back home. I was so sorry to come here. I went to one home and I showed them everything in my suitcase, and they asked me how much it cost and I used one finger and they bought everything from me. They gave me the money, and I didn't know. I was lost. I was worried. The people took everything."

(Jamal said that he thought that he lost the money, but his brother found it.) "He counted the money, and he finds I make $10. He said that even if you make a dime, that is good. Even when I come home in the evening, they asked me did I make anything? My brother said I made $10, and everyone was excited. That was a lot of money.

"Believe me, after that, I started to go out and start making money, maybe $30 a day. That was a lot of money.

"The other people who came with me, they had to spend a lot of money to come here, so they were afraid to go back. They wanted to go out and make money. My brother wanted to go home. But he said look at me, 'I am old. Would you like to see me spend the rest of my life like this?'

"When I first came here, I wanted to come to America. But it was difficult. You could not speak the language. But the more you stayed, the more you liked it here.

"One time, I was at 22nd and Leavitt Street. I wanted to take the streetcar, and the streetcar man told me to take the Wabash (line). He tell me to take Wabash, and I take it and I get off at 18th and Wabash. And it was night time and rainy, and I looked around and I didn't know where I am I met one man who saw me, and he knows I am lost and he said 'You want to stay?' I started walking. I didn't know where I was.

"I remember being with Hassan Haleem. He went over there to the old country and was married and then he brought his family to Chicago.

"I thought maybe I should go back (to my country) many times. I wanted to go back. I was worried. Would I survive?

"We arrived in Chicago by train at Michigan and 12th Street, and we come off the train and we took a taxi to that store at 51 East 18th Street. It was early in the morning at six o'clock, and the store was not open. We were just standing there, and we didn't know where to go. So here is an old man who also spoke in Arabic. He asked, 'You Arabic?' I said yes. We followed him to the coffee shop until the store opened.

"As soon as they would come in, they would get you a suitcase and merchandise, and even if you need some money to send back to your family, they would give you money and later on they would take it back from what we made. Some people needed to send money to their father or their family and they would help.

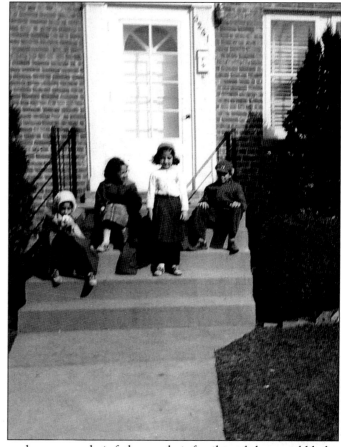

"We would meet at the coffee shop at 18th and State Street. I think it was called Kahwah al Isbitan, or the Welcome House. After that they had another coffee house at 18th and Michigan. This was the only place, although sometimes we would meet at the wholesale store and talk there. When the holidays would come, like Ramadan, we would get together and pray. There was a religious man named Sheik Mohammed Yusef who would come and perform religious services for us and read from the Qur'an and pray and for Ramadan. We would meet for the services at the coffee house. When we wanted to pray, they would take the tables and move them to the side and then we would pray. The Imam would stand there and lead the service. We did not have a mosque in Chicago where we could go.

"We would get together with the Syrian Arab community on the north side. They would have wholesale and stores and all of it was Syrian jewelry. And they were friendly, and they spoke good Arabic, too. The Palestinians and the Syrians would always get along. We never had any trouble at all. We never had any trouble with the government here. We always worked hard. We would rather stay hungry and never do anything wrong. The religion was important but also there were people we could depend on to help us. So we did not get into trouble.

"Today it is different than it was before. Before, the men were all single. We had to leave every day, every day. Today, each one is with each family in their own home and in different section of the city. Later, I know a lot of them, but I would not see them for years and that was very hard. Hard. They were not so close together like before. That's why they had to build a mosque. Before, we were all single, and we had no place except the coffee house. We would all get together. From Ramallah. Beitunia. From all over. We didn't care. We needed each other."

Jamal Kateeb's daughter, Linda Kateeb, pictured here, told the following story:

"At the eager age of 19, my father Jamal left his mother, father, and four sisters in Beitunia, Palestine, in 1921 to come to America. His two older brothers Musa and Hasan, who'd already established themselves as door-to-door salesmen in Chicago selling ladies' clothing, sent for my dad so he could learn the business. He would distinguish himself with his tremendous work ethic, perseverance, and kind heart, which would continue until his death in 1977.

"On October 20, 1946, he married my mom Subhiya Jadallah, a baker's daughter who was 21 years old. After honeymooning in Beirut and Damascus, they returned to live in Jerusalem with my mom's parents until they came to America, the land of opportunity, in April 1947. For a time, they lived in a cheap hotel on the north side of Chicago. Then my dad's cousin, my uncle Albert, had an empty upstairs apartment in his building at 35th and Halsted and invited my parents to rent it, which they did. After Uncle Albert's business partner went back to the Middle East, my dad gave Albert money so he could repay his many debts. Despite the fact that my dad's children now numbered four (the last one, the fifth, had hydrocephalus that caused him to die shortly after birth), his generous spirit motivated him to work a little harder and provide the money for my grandmother and mom's two nephews (whose father had recently died) to travel to Chicago to live with us.

"In 1954, my dad bought our first house on 92nd and Peoria on Chicago's South Side for $13,000. Our family of 6 lived in this 2-bedroom, one basement, one bathroom house for 13 years. My mother helped out by starting a factory job at Nabisco in August 1956. There she continued to work until she retired in June 1990.

"A quiet man always interested in politics, my dad took delight in reading the newspaper every day and watching news programs on TV. He created a comfortable life for his children. Hussien is a factory worker at Nabisco; I (Linda), an educator and staff developer, am completing data analysis on my dissertation; Norma (recently retired) worked as an administrative aide at UIC; and Mimi, the youngest (deceased), in addition to working as an administrator at UIC, tirelessly planned and developed projects to support her Palestinian people." (Photographs courtesy of Linda Kateeb.)

George Hanna Hanania

George John Hanania (back, standing), born in Jerusalem on November 11, 1903, immigrated to Chicago in 1926, following his brother, Mousa (Moses), who arrived about 1922. Their father, Hanna (John) Mousa Hanania, lived in Jerusalem off Jaffa Road and was married to Katreena Jyries Cattan. George had two older brothers, Yusef (Joseph) and Mousa, three younger brothers, Khamis, Farid, and Edward, and two sisters, Ellen and Helen. The family was related to Jyries Hanania, the founder of *Al-Quds* newspaper in Jerusalem and to Judge Hanania Hanania, a Palestinian magistrate in Jerusalem.

George attended the Ratisbon's School (1912–1914), American Mission School (1915–1917), Eccles des Freres, and St. George High School (1914–1920), and studied law at the Palestine Patriarchal University (1923–1926). Due to the British control of Palestine by mandate, English was taught as a second language to nearly all Palestinian Arabs. Yusef and George worked at the Jerusalem Post Office where George was employed from June 23, 1920, until August 31, 1926. Yusef drowned at the Jerusalem Quarry in April 1926, at a time when Arab and Jewish relations were simmering. According to the police report, Jewish, Muslim, and Christian bystanders heard Yusef's cries for help, but did not respond. Jews thought he was Muslim. Muslims thought he was Jewish. Christians thought he was not Christian. The event typified the animosity growing in Palestine between Arabs and Jews, most of whom immigrated to Palestine from Europe.

In the mid-1920s, employment conditions in Palestine were very poor, influencing George Hanania's decision to leave Palestine for the United States. Mousa had been urged to seek work in Chicago by his father, who had worked at the New York Centennial Celebration and at the 1893 World's Columbian Exposition. Mousa joined a cousin, also named Mousa, and lived in an apartment at 2100 N. Clybourn Avenue. He later worked as a cook at the Rolling Green Country Club in Arlington Heights. A newspaper article published at the time reported that the country club was robbed and that a significant amount of money was taken from the employees, including Mousa, who lost $800. After Yusef's death, George and his siblings found it difficult to obtain work. George, working part-time, tried to find another position with the government for himself and his sister Ellen. His applications to the Department of Health were turned down, and his sister Ellen also failed to find work.

When the Jerusalem Post Office refused to give him time off to finish Law College, he decided to join Mousa in America, "the land of the free." He was given a Laisser Passer document, permitting his immigration to the United States. It was the only document that identified him as a Palestinian (see page 8).

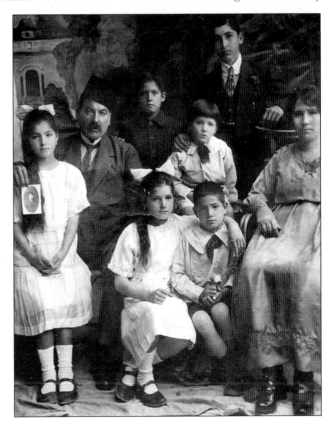

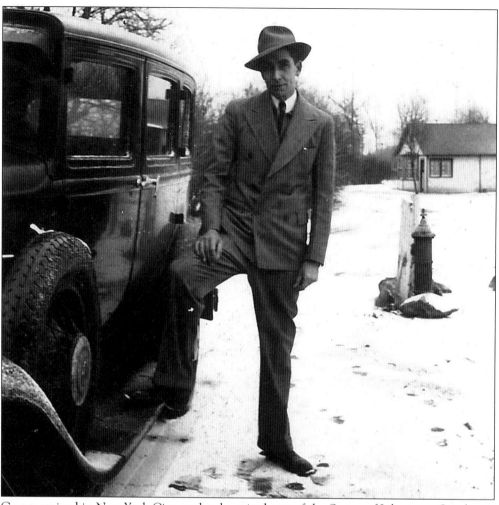

George arrived in New York City, under the raised arm of the Statue of Liberty on October 4, 1926, aboard the S.S. *Sinaea* passenger ship along with many other immigrants, including Arabs and Jews. He always recalled it as an inspiring site. After an expensive month-long trip, he arrived at Chicago's Union Station where he was met by his brother.

While in the United States between 1926 and 1929, George worked at the Fenske Brothers Center (on North Clybourn), the Astor Street Theater, and the LaSalle Street Theater. Eventually, Mousa helped him find work at the Rolling Green Country Club in Arlington Heights where they worked together from 1930 through 1940. In 1934, George received his U.S. citizenship, and apparently, it was either in the late 1930s or 1940s, that his father died. When World War II broke out following the Japanese attack on Pearl Harbor on December 7, 1941, both brothers enlisted in military service. Mousa entered the U.S. Navy. George had just started a job as an accountant at the Sinclair Oil Company in early 1941, and the company was supportive of employees who left their jobs to serve in the military. He entered the U.S. Army and was assigned to the Office of Strategic Services (OSS), which was the precursor to the CIA. George was assigned to manage communications and telegraphs, something he learned to do at the Jerusalem Post Office. He also served as an interpreter. While in active duty, George traveled throughout Europe, returning several times to visit with his mother in Jerusalem, Palestine. During the war, he left extensive writings on his experiences in the service, describing the places he visited in both letters to his brother and sisters.

34

George was honorably discharged in 1945. The following year, he married his military sweetheart, Walbert "Wally" Mueller, in a double ceremony with Wally's brother, Clinton Mueller. Their first anniversary celebration was reported in the local Arlington Heights *Herald* newspaper. But on Christmas Eve, 1947, Wally died. In early 1952, George was encouraged by his sisters and brothers to go back Palestine to find a bride. He was introduced to a tailor in Bethlehem who had a young daughter.

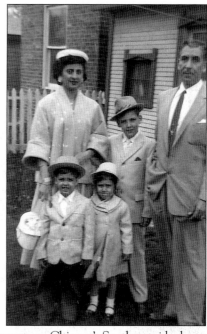

George was escorted to the home of Saba and Regina where he was introduced to Georgette, 19, the eldest of four sisters and two brothers. They were married two months later on June 1, 1952, and spent a month with cousins who had fled the conflict in Palestine and were living in Baranquilla, Colombia, South America. They purchased their first home in Chicago at 9905 S. Forest Avenue near Southport Avenue (now the Rev. Martin Luther King Dr.). In 1959, they moved to 8928 S. Luella Avenue and later to the Southwest suburb of Burbank in 1968. (*right*) This *c*. 1959 Easter photograph taken in the back yard of their home at 89th and Luella Avenue on Chicago's Southeast side shows Georgette Hanania (from Bethlehem), son John, George Hanna Hanania, the author Raymond, and sister Linda.

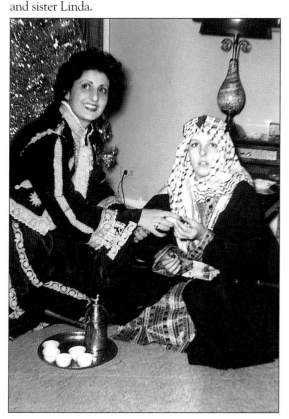

(*left*) Georgette and son John act out a traditional Arabian Christmas in 1961 in their Luella Avenue home on Chicago's Southeast Side in this photograph. Like many Christian Arab families, George and Georgette were very religious, but they did not have access to an Orthodox Church where they could worship in those early years, or where they could send their children. At first, the children attended a Baptist Church on Stony Island Avenue, where they were baptized.

Later, the children registered at Bethany Lutheran Church at 95th and Chappel. Sometime in the mid-60s, a new Orthodox Church opened in Oak Park. George Hanania died in August 1970. He was buried in the South Side's historic cemetery Oak Woods, next to the body of Mousa and his mother, Katreena. Georgette Hanania died 15 years later in July 1985. She is buried in the Evergreen Park Cemetery, which includes a Muslim section where hundreds of Arab American families are today buried.

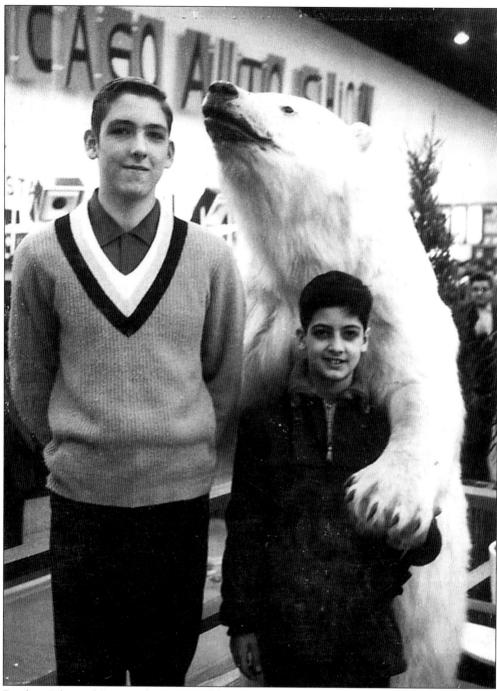

Brothers John and Raymond are pictured here at the Chicago Auto Show around 1959 or 1960.

OMAR DIAB HASSAN

Omar Diab Hassan's daughter, Leila Diab, offers the following story:

"My father, Omar Diab Hassan was born in Beitunia, Palestine, in 1910 and passed in 1996. He was a successful businessman who worked side by side with my mom in the women's apparel business in the heart of Chicago's Loop, and later in Phoenix, Arizona. He never hesitated to speak very proudly about his Palestinian heritage. He kept his culture alive, especially through the eyes of his children, with Americans, and with the Arab community.

"In 1926, at the young age of 16, and all by himself, my dad boarded a ship bound for America to escape economic depression under the oppressive British mandate over Palestine. Soon after arriving, he journeyed to Chicago to join his older brothers who spoke of a vast land with many great economic opportunities. My dad learned from his brothers and other immigrants that the opportunity to succeed in business were self-made dreams.

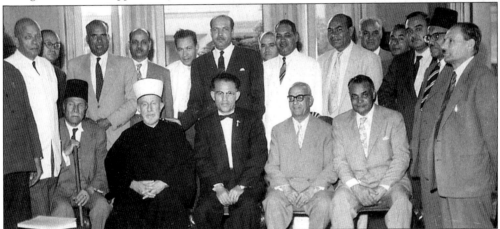

"Omar Diab Hasan opened a dress shop in Tyler, Texas, called Lorraine's Fashions. He sold women's lingerie, dresses, and undergarments. The local newspaper took note and featured him in a story about this new Arab immigrant who came to Tyler. Over the years, my dad developed a remarkable professional talent for design, style, and common trends in the world of the fashion industry. In the early 40s, and later throughout his professional fashion career, my dad was one of the very few Arab immigrants who established his own wholesale and retail fashion business, which was in a predominately Jewish fashion industry. Years later, I was to meet many of my father's best friends, who were Jewish. They adored my father and his ingenious business savvy. My dad's business trademarks were his creative eye for merchandise and new trends in the world of fashion. His success in the world of fashion were also influenced by his many travels to foreign countries, and his attendance at several of the style shows in New York, London, Paris, Rome, Taiwan, and China.

"In the early 30s, he married Dorthea, an American woman from Red Oak, Iowa, who was studying at the Art Institute of Chicago. They had two children, Miriam and Ali. Their mother died when they were only two and four years old. Twenty years later, my dad married my mom, Holliday (Khalidah), an Arab-Turkish American from West Virginia. They had three children, Reyaud, Elmaza, and Leila. Today, Miriam is a Christian social worker. My brother Ali is a doctor with four degrees. He first became a veterinarian, and later a surgeon, psychiatrist, and a lawyer, and lives in Sacramento. Reyaud (Rey) is a lawyer in San Franciso. Elmaza (Mazi) is a fashion consultant and owner of Mazi's Boutique in LaJolla, California. The youngest, Leila is a freelance journalist and an educator.

"My dad's vision of Arab unity, building a better understanding of Islam in America (he was cited in the 1960 Arabic book, *Al Islam in America*, written by Dr. Mohammed Shawarbi), helping people, and finding a just solution for the plight of the Palestinian people, were all driving forces in his life. I'm proud to say, that my dad met with Arab presidents, dignitaries, kings, and the common people to hoist his concerns for the Palestinian people, the Arab/Muslim world and his community. He gave generously and willingly to Palestinian children's charities; saw the need to financially support the purchase of land for the site of a mosque; and got involved in local and national U.S. politics.

"My dad would often recall our roots and in storytelling fashion would humbly say, 'the Diab-Hassans are the descendents of Saladin Al Ayubi, the 11th century Muslim Crusader. We come from branches that are treasures of memories to behold. We must never forget where we came from.'"

Leila Diab's poems and published work on the Middle East, multicultural issues, and women in Islam have appeared in several local, national, and international publications. She is an adjunct faculty member at Moraine Valley Community College and teaches World History, English as a Second Language, and English literature at the high school level. She also owns Cavilier Communications Network, a global media consulting firm.

KHALIL SULIEMAN ZAYID

Khalil Sulieman Zayid first came to Chicago in 1939 and served as the Arab American community's first Imam. By then, there was a strong Arab and Muslim community growing around 18th and Michigan Avenue. Like many of his counterparts from the Middle East, Khalil left his home village of Beitunia because of the poor conditions and the terrible economic times leading up to World War II. He also was concerned about making a better life for himself and his family, which remained in Beitunia. His brothers and father pulled money together to pay for his trip.

"He used to tell us the story of how a Jewish tenant of one of his father's buildings helped him fill out the paperwork so he could come to this country," recalls his daughter, Miriam Zayid Zayed. (In 1971, Miriam married Refat Zayed, a distant cousin who came to the United States to flee Israeli persecution after the 1967 War.) "He would tell us the stories of when he came to this country. When he got here, he stayed with Hassan Haleem and others. They helped him by giving him a suitcase with a permit sticker on it and they told him to go sell. He said he didn't know how to do it or how to get the people to open their doors so he could get them to look at what he had in his suitcase and sell it to them."

But he learned quickly. "My dad lived in a rooming house with Mr. Haleem. Every penny he made, he sent back to his family in Beitunia. They used the money he sent them to purchase land with it back home and that helped them have a better standard of living and life. It made a difference for them. They weren't rich but they were living comfortable, thanks to what my father was doing," Miriam remembers.

"In 1947, my father went back home to Beitunia and he married my mom, Shamsa, in 1947. They came here to Chicago and she lived with him on 18th Street for a few years with Mr. Haleem, until she had her third child. That's when they decided to buy a home. You have to remember, the mentality back then was that they were here to make money and then go back home." Khalil was among the founders of the Mosque Foundation, which was formed in the 50s to help raise money to build a mosque. The Mosque Foundation purchased an old Church at 65th and Stewart and used that as a school and community center.

"They didn't have Friday services because they didn't have a full-time Imam to conduct the services and they didn't have a mosque," Miriam recalls. "But the community center at 65th and Stewart was big. I went there. There were only a few Muslim families in Chicago when I attended the school there and when it opened up. I was very young but I remember going there often. It was the first Arab Muslim center there. I think there were only about 50 Arab Muslim families in the Chicago area at that time."

Miriam recalls, "The Muslim community also rented a conference hall at the YMCA at 71st and Exchange Avenue in South Shore where they would hold special holiday services for the Eid (Holiday) and the Eid el Udha (High Holiday) associated with Ramadan, the holiest period for Muslims. The community center at 65th and Stewart was nice. It had a school. It was really big. We were young. They taught us our religion, different verses from the *Quran* and they also taught us the Arabic alphabet." The 65th and Stewart center was sold around 1964, and the money from the sale was used as a down payment on the purchase of land at 91st Street near Harlem Avenue, the location of the current Bridgeview Mosque. In the mean time, they converted a store front at 79th and Clyde Avenue in South Shore as a new community center.

"We would hold Arabic classes and religious classes there. And, people were married there and they would hold their ceremonies there," Miriam recalls.

"The Arab Muslim community was growing and they would bring in an Imam from Detroit to do the special events like all the marriages and all the funerals. We didn't have Friday services back then."

As the community expanded, there was a growing need for someone to conduct religious service on a regular basis. In 1966, members of the Mosque Foundation asked Miriam's father to serve as the Imam. A very devout Muslim, he learned in Muslim scripture and the *Quran*, and also received instruction and eventually a certificate through the Jordanian consulate. He could not drive, so when Miriam got her driver's license at 16, she drove him to and from services and community events.

"His first service was conducted in 1966 at the mosque at 79th and Clyde. We couldn't do the service every Friday because it was difficult for the community to close its stores early and come to service. The mosque really served mainly as a community center and a religious center. We could conduct services on special occasions there. Weekly services didn't start until sometime in the mid-1970s when the community really started to grow and there was a stronger drive to have them," Miriam remembers.

Sometime in the late 1970s, the building at 79th and Clyde was sold, and the community started to hold services at the Golden Age Restaurant at 95th Street just east of Cicero in Oak Lawn. The money they made was also put down on the land in Bridgeview, and the founders of the Mosque Foundation dreamed of someday building a mosque where services, schooling, and religious education could be offered professionally and on a regular basis.

Miriam grew up around 79th and Halsted. In 1972, her father purchased a home in Burbank. He died in 1988. Today, Miriam is a teacher in the Chicago Public School system, and she works as a volunteer and precinct captain in the Orland Township Democratic Organization. She ran for public office in the suburbs several times. She is pictured above (second from left) with Congressman David Boniors, Saffiya Shillo, and Tipper Gore.

40

FRANK J. FAKHOURI

Frank J. Fakhouri was born in As-Salt, Jordan, and obtained his bachelor's degree in physics, chemistry, and biology. He completed two years of medical school at the University of Syria and eventually immigrated to the United States in the 1960s, settling in Detroit, Michigan. He pursued his medical degree working three shifts at three different hospitals as a lab technician six days each week. After paying his loans, he traveled back to Jordan and married Odette

Mashni, who was from Amman, Jordan. She was a high school graduate and an active member of the Young Catholic Association. In 1978, after traveling to San Diego, Fakhouri moved to Chicago where he helped open a supermarket. His family includes Gabriel, a Democratic Party activist, and a brother Joseph who died in1989. They also have two sisters, Janet, a naturopathic doctor and JoAnn, who is a production assistant for movies that are filmed in Chicago. (Photograph courtesy of Gabriel Fakhouri.)

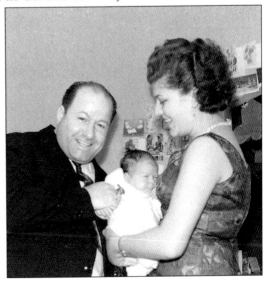

(*right*) Frank and Odette Fakhouri are pictured here holding their newborn son Gabriel in this early 1970s photograph. (Photograph courtesy of Gabriel Fakhouri.)

NICK KHOURY

Nick Khoury was born in Jifna, Palestine, a village located north of Jerusalem, in 1921. His father died when he was three years old. Supporting the family was left up to two older brothers, Nick, and one younger brother. The Khourys were influenced by the presence of the Lutheran Mission in Palestine. An older brother became a school teacher and eventually a Lutheran pastor. Nick was educated at the Schnellei grammar/high school, which was set up by German missionaries in 1853 in Jerusalem. Contacts he made in the Lutheran community helped him when he made his decision to immigrate to the United States in 1952, when he was 30 years old.

"I had a good job when I left Palestine. I worked as a maintenance supervisor at the Augusta Victoria Hospital located on the Mount of Olives in Jerusalem," Nick recalls. "The hospital was named after the wife of the German Kaiser Wilhelm, who had made a noticeable presence in Palestine prior to World War I. Money from the hospital was used to support a girls' orphanage in Palestine at the request of the Kaiser's wife.

"I started out in the 40s as a diesel mechanic working for the Jerusalem Motor Supply Company. Because my father had died when I was young, I was independent and had to work for everything that I had."

Nick was motivated by two factors to leave his good job, family, and country, and to embark on a journey that was full of uncertainties. "All I ever wanted to be was an engineer. And, I worked with someone, I think he was Czechoslovakian, who kept telling me that I was too smart to stay here. He said I should go to the United States where the opportunity to make money was greater. He planted the seed in my mind that if I came to the United States, I could become an engineer."

Despite the encouragement, he had received letters from a cousin and the brother of a friend who cautioned that talk of "money being in the street" in America was exaggerated. "He said that it was tough to make it, and I would have to work hard. But, I believed in my own dream." After World War II, U.S. immigration laws were tough. It was difficult to obtain a visa to immigrate to the United States. In 1947, conflicts between Arabs and Jews increased with war breaking out on May 14, 1948, and the occupation of a large part of Palestine by the Israelis. Nick's village remained in the area controlled by the Arabs and was placed under the control of the Government of Jordan. Augusta Victoria Hospital was taken over by the Red Cross. The Israelis had captured the electrical station, and the hospital, located across the new border, could not get electricity from the plant. Eventually, they had to set up a new electrical power

source, and Nick was put in charge of its operation and maintenance. Later, the hospital was taken over by the United Nations.

A friend of his had a son who was attending Utah State University, in Logan, Utah. "I decided that I was going to apply as a student to study in the United States. And, I decided to apply to Utah State, to their engineering school." Nick was accepted.

Nick remembered saying goodbye to his mother and brothers. "They asked me, why should I leave? I had such a good job. Good work. I was making very good money. I had made up my mind. But I was determined not to fail because I knew that would be a great embarrassment to have to return as a failure. I couldn't fail." In the summer of 1952, he boarded a plane from Jerusalem, stopping in Beirut, Lebanon, where he met briefly with another brother, Sammy, who had traveled to see him off from Damascus, Syria. I boarded a TWA plane that took me to New York City."

In New York, his contacts with the Lutheran mission in Palestine had paid off, and he carried a letter from the director in Jerusalem to the director at the New York office, asking for help. "This entire trip wasn't really planned. I knew were I was going, but I was unsure of how to get there. I didn't experience something like this and I remember sitting on the plane, very scared, afraid that it was going to crash into the ocean before I got to the United States. When I got to New York, it was very confusing. I arrived at the noon hour. The buildings were so tall. Everyone was in a rush. It was crazy."

The director at the Lutheran World Federation in New York helped him reserve a seat on a plane that took him to Flint, Michigan, where an uncle and a niece he had not seen in six years lived. After visiting with them, and with their help, he purchased a bus ticket that took him to Logan, Utah. He arrived too late to start the semester and immediately found a job working at the Chrysler factory. Working on the side and going to school, Nick completed his degree in engineering, graduating in 1956. While at school, he had met other Arabs from the Middle East, but to improve their English, they all agreed not speak Arabic with each other.

As a student, he was required to return to his homeland. That was the promise he had given the American Ambassador who approved his visa in Amman, Jordan, back in 1952. But, in the States, he went to the local immigration office and asked for an extension. Needing engineers to stay, they offered Nick the opportunity to become a permanent legal resident, which he accepted in 1957.

Nick had decided he would drive from Utah to Detroit, where he planned to live near other relatives and friends. But his car broke down in Omaha, Nebraska, and he spent most of his remaining money that he had saved getting it fixed. He managed to drive to Chicago, before he ran out of money and gas.

"I had a job offer in Detroit from Autolight, which made spark plugs and things, and I wanted to get there. But I ran out of gas in Chicago and found myself with no money here. I started looking around and went to the office of International Harvester where I convinced them to give me a job. I stayed at the YMCA at 826 South Wabash. I didn't know any Arabs here at all. It was strange too, but I felt more comfortable because I had been in the States for more than four years, now."

In 1958, Nick was hired by Continental Can Company. He worked in numerous positions including in the research engineering department. He worked for Continental for 25 years before retiring in Chicago.

Nick was a supervisory part of the team that helped change American culture, developing the pop-top for cans. "Back then, it was called the 'easy open end,' and it was something that changed how we consumed drinks and refreshments." Eventually, in 1964, Nick designed and was awarded the patent several years later for another invention that helped American homemakers—'full opening end,' which allowed consumers to snap off the entire top of a can for food products like sardines, peanuts, and other perishables.

MOHAMMAD HUSSIEN

For centuries, inviting Arabian recipes have been provided by great Arab chefs. One of the most renowned in Chicago was Mohammad Hussien (he spells his name slightly differently from the traditional Hussein). Hussien worked for more than 40 years at the world famous Berghoff restaurant. Hussien entered the "Door of God" the same way other Arab American immigrants came to Chicago and rose to become one of the city's greatest chefs.

Mohammad Hussien arrived in Chicago during the second big wave of Arab immigration to the United States. He set foot in Chicago on July 24, 1954, at only 16 years old. "There really was no future back home, and I came here to see if I could make a career for myself and earn a good living to support myself and my family," says Hussien.

"I remember meeting American kids back home, and they would tell me all kinds of stories about the opportunities they had in America and the schools and the education they would get. I wanted that, too."

Hussien recalls how tough it was in the 1950s just after the first Arab-Israeli war destroyed more than half of Palestine. "You have to remember, that during the war, schools were closed for many years after. The schools were occupied by the military. The Israelis occupied the schools on their side, and the Jordanians used the schools on our side as headquarters," Hussien recalls. "The Beitunia school was occupied by soldiers, and we had to go to the Ramallah schools for a while, when they were opened."

He flew from Jerusalem Airport to Beirut Airport, and caught flights to Paris, New York, and finally Chicago. "I remember it being a very tough flight. I could speak only just a littler English and no French at all," Hussien remembers. "The toughest part was when we landed in Paris. I was lost. I didn't know what to do."

Hussien arrived in as a penniless immigrant. His brother immigrated the year before and attended Indiana University. "My father told him that he could only come here and work. And work he did," Mohammad recalls.

"My family had a large farm in Palestine. We grew fig trees and grapevines. We would get up early and work the orchards, picking the figs and in the fall picking the grapes. We had to pick every day. What we picked in the summer, we ate in the winter. That's how we lived. My parents got the land from their grandparents, who got it from theirs. We all worked it, also raising some animals. They said Palestine was a barren place of rocks and desert. That's not true at all. We had a beautiful farm. It was some 320 dunums (80 acres). When we weren't picking the figs from the trees, we were clearing the land to grow more. That's all we did. It was hard work, but it was our family and it was the way we lived."

Hussien said the first two months in Chicago were rough: "I couldn't find any real work. It wasn't easy to get a job. It was the summer, and all the American kids were out of school, and they got all the jobs. So there were few available."

But when the summer ended and the students returned to school, Hussien found himself at the door step of a well known Lebanese American merchant who had set up a wholesale merchandise shop on Adams Street near Franklin Street in downtown Chicago.

"I went to Aziz Shaheen, like many new Arab immigrants did," Hussien says. "As I remember it, Shaheen had a factory in Georgia where he would get a lot of merchandise. All the Arabs would go to his store in Chicago and buy their merchandise, usually on credit, and then pack it up in a suit case and then walk the streets of Chicago selling. Peddling. It was hard work."

Hussien said that peddlers were required to get a permit from the city first, usually through the local alderman. "I would say 90 percent of all the Palestinians would start out that way. We would sell women's clothing, slips, hosiery, brushes, items that you couldn't just walk to a local mall or shopping plaza to buy because malls and shopping plazas didn't exist. So there was a need for the peddlers back then," Hussien said. "It wasn't an easy life. I remember those few months, walking all day and all night, knocking on doors. Most people were polite. Some would buy products. But you would have to carry this big suitcase all day. I was just 17 years old at the time, and I only weighed maybe, 100 pounds. I couldn't sell the heavier items that others sold, and I stuck with the women's clothing. The items were lighter."

While peddling, Hussien met another Palestinian, Jaleel Al-Baker, who also originated from Beitunia. They became good friends. "Jaleel worked at U.S. Steel, and he took me in to see his supervisor, but his supervisor said I was too skinny," Hussien recalls. "At night, after leaving U.S. Steel, Jaleel would go to a restaurant where he worked a second job. You had to have two jobs in those days just to make ends meet. Jaleel took me with him, and he convinced the night manager to hire me. And on September 24, 1954, exactly two months after I landed in Chicago, I was hired at the Berghoff Restaurant, which was considered one of the fanciest restaurants in Chicago at the time."

In those early days, people used to travel downtown not just to work, but to relax and eat at one of the many fine restaurants. Again, the lifestyle was different back then. There were very few restaurants in the neighborhoods and the suburbs did not exist yet. The only place to go was to the Loop. That's where the restaurants were. That's where the shopping was. That's where the movie theaters were. And that's where all the popular stores were located. Mohammad remembered walking downtown one night after arriving in the United States and hearing Arabic music playing from a record store downtown.

"I used to go to night school to improve my English, taking a bus to 62nd and Stewart. One day, returning downtown, I was walking past the Chicago Theater. There was a deli there, and there was also a record shop. I could hear Arabic music playing from the store so I went inside. I met the owner, and he told me he loved Arabic music because he lived in an Arab country. He had been born in Syria and then immigrated to this country, too. But he was Jewish. His language was Arabic, though, and we talked all night.

"The day I started, the chef asked me if I could speak English. I said I could. He asked me, 'Are you here to just make money or do you want to make a career out of this?'" Hussien remembers from his first day on the job at the Berghoff. "I said I wanted to make this a career."

The chef, who took Hussien under his wing was a world famous chef at the time, Karl Hertenstein. He was also Jewish, though the owners of the Berghoff were German. "I remember him asking what my name was, and I said Mohammad. He asked me if I wanted to keep my name, and I said 'Yes, that is my name.'" Hussien says that the issue of religion and race did not come up at the Berghoff, and even though the chef was Jewish and he was Palestinian, he said everyone got along well. "The chef was very good, and he taught me a lot," Hussien recalls. Hussien started out as a busboy, but that only lasted three days. "I didn't like doing that at all. I had to mop everything everyday. The mop and the bucket was heavy and taller than me. Finally, they said they would put me in the kitchen as a runner, carrying food from the kitchen to the cafeteria."

The Berghoff served between 1,500 and 2,000 people everyday for lunch just in the cafeteria. The restaurant also included an upper scale dining room, too. "Then they moved me to the kitchen where I helped make the salads. And in May 1955, I was promoted to the post of short order cook," Hussien says. "Those days, everyone ate meat. Steaks and lobsters. We started to see a lot of conventions coming to Chicago, and the amount of food we cooked increased dramatically." They were now serving as many as 3,500 people at lunch time. At every job, Hussien learned something more as a cook. Between 1957 and 1958, he learned how to cook soups and sausage. Later, he learned how to butcher the meat, which is an important skill in becoming a chef.

"When I started, they only had two chefs on two shifts. But in 1958, the Berghoff family decided they wanted to hire another chef. That's when they decided to give me the job as the restaurant's third chef," Hussien says. In 1968, Hussien was given a promotion and put in charge of a new restaurant the Berghoff family opened at 125 N. Wabash Street, also downtown. The second restaurant only lasted fur or five years, and when it closed, Hussien returned to the main restaurant where he worked on the night shift for another 10 years. In 1978, he was named the restaurant's new executive chef when his mentor, retired. "The Berghoff family used to work with us side by side," Hussien said of the famous Chicago family.

Many Arab Americans who arrived in Chicago found jobs working at restaurants in

downtown Chicago, Hussien says. And as his notoriety grew, people would tell new arrivals who were looking for jobs to "go see Mohammad at the Berghoff."

The Berghoff family itself was a family of immigrants to this country. The family opened the restaurant on April 14, 1898, at the corner of State and Adams Streets, later moving to 17 West Adams in 1905 where it is located until this day. It originally opened as a place where the Berghoff family could sell their special band of German made beer that was brewed in Indiana. But the family sold the brewery in 1954, the year Mohammad Hussien walked into the restaurant seeking work.

Hussien remained at the Berghoff from 1954 until his retirement in 1995 as the chief chef at the Berghoff and as the longest continuously serving employee at the business. Today, Hussien and his wife Hurriyeh have five children: Sana'a, who is a lawyer, Maisoon, who is married into the Haleem family, and Summer, Yaqub, and Suha.

In memory of his homeland, Mohammad bought a fig tree from a neighbor of his who also lived in Chicago Ridge. He planted the fig tree in his back yard. "Every year, I take figs from the tree, and I remember working the fields on our land back home in Palestine. It is a nice memory. I loved that time very much. It's hard to keep the tree here in the United States, because of the winter and snow, but in the fall you can cover the tree in dirt, and it survives each year after. It shows you how things can adapt to almost any environment if it has some help." It was a lesson that Mohammad learned and never forgot.

RAFIQ SWEIS

Rafiq Sweis was born in Amman, Jordan, in 1946 in the midst of the worst outbreak of fighting between Jews and Arabs. He attended the Patriarchal Seminary of the Jerusalem Branch of the Lateran University, which was based in the Vatican in Rome, studying to be a priest. In 1969, his older brother, Barjas, immigrated to the United States, settling in Los Angeles. "Barjas was the first of the family to come to the United States. He went to Los Angeles, at first, because that is where his wife's family had also immigrated a few years before. He went there looking for a decent life, better economic conditions and job opportunities." Rafiq said that Barjas had written back often to his family in Amman, telling them about the opportunities that were available in the United States, although he missed his homeland and also conceded that life in the United States was not as easy as everyone had said. You had to work, but the work was available. "He encouraged us to come to stay with him. I think it was out of missing us, but also because he believed we could do better here. He opened a liquor store, gas station, and a mini-mart while he was here, and he made good money. As Arabs, we are always willing to work long hours, as a family, to make our businesses successful."

Like his brother, Rafiq was prepared to come to the United States because they both spoke English well. "It was mandatory in our schools. The British had controlled the lands under the mandate for many years. But especially in the seminary, I was required to take three languages." Rafiq can speak Arabic, English, French, Italian, and Latin fluently. "I was close friends with the U.S. consul general in Amman, Bruce Jackman, and I worked as a government translator, translating documents on many occasions for the king, the prime minister, and many of the cabinet members. They encouraged me to come to the United States, believing that I would do well."

In 1972, he boarded a direct flight to Los Angeles from Amman. Two years later, he married a distant cousin, who was already in Los Angeles. He found a good paying job with the Immigration Department as a translator.

"At first, it was difficult to adjust to the new customs here. It was very different. I tried to be faithful to my customs, the ones we were used to as Arabs, speaking the language, eating the food, attending church services, but it was difficult. There was constant pressure from this country to change. We also had to learn new laws that applied here. They were different to us, especially seeing the freedoms that people had that we did not have back home. Things back in the 1970s were different than they are today in the Arab world, and things have even changed in this country, too."

In 1978, Barja's wife was diagnosed with cancer, and the doctors advised her and her husband to move east to Albuquerque, New Mexico, where the dry air would ease her suffering. "We were doing well. We drove to Albuquerque in our 1974 Cadillac. My brother, his wife. My wife, and my two children. At first, we enjoyed the weather in Albuquerque, but we found that the city was too small. We did learn how to spell the city's name, though."

In 1982, they drove to Chicago where relatives and friends told them they would find more work. In 1983, Rafiq opened a grocery store at 345 W. 95th Street. "We opened the store in the black community because we found that we received a better response from them than we did in white communities. There also was more opportunity, and the need to open small grocery stores was there, while it wasn't so strong in the white communities." In 1989, he opened a new store on South Michigan Avenue, and he purchased several abandoned buildings for investments. In 1995, he opened a Goodyear dealership franchise in Niles on Milwaukee Avenue, and in 1997, he purchased the Oasis Restaurant (pictured above) at 9052 S. Harlem Avenue, around the corner from the Bridgeview Mosque.

Rafiq served four terms as the president of the El-Fuheis Jordanian club (named after a village in Jordan near Amman).

JALIL SALMAN

Jalil Salman arrived in America in the 1960s from Fuheis, Jordan. Like many Jordanian immigrants, he immediately became active in his church, St. George, and also with the Jordanian and Fuheis American Associations. Jalil was considered one of the patriarchs of Chicago's Jordanian American community. He and his wife Estir raised their children to be American. Salman is pictured here with his wife and a daughter at the al-Khayam Restaurant located at Foster and Western Avenue in Chicago, in 1992.

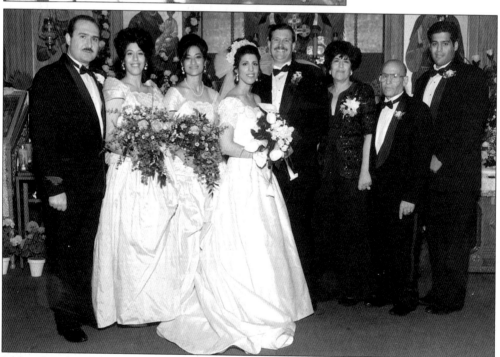

Jalil and Estir Salman pose at the wedding of one of their daughters Rita, in October 1994. Their son Faisal is on the far right.

Four

LEADERS, ACHIEVERS, AND ACTIVISTS

RELIGION

Chicago's Arabs are equally divided between Muslims and Christians. Although there are reportedly seven million Muslims in the United States, only about 22 percent are Arab. Just as Christianity finds its original roots in Judaism, Islam finds its roots in Christianity and Judaism, with Muslims recognizing Jesus, Abraham, and Moses, for example, as prophets. While Christian Arab immigrants could easily assimilate into American society through local churches, Muslims gathered in storefront mosques until their first mosques were built. The word "Allah" is often misunderstood as a reference to a different God than of Christians and Jews, but in fact, it refers to the same God. The word Allah is merely the Arabic word for God. Christian Arabs who pray at the Church of the Nativity, which marks where Jesus was born, use the term Allah just as do Muslims.

One of the most popular South Side mosques in the 1970s was located on the second floor of a storefront at 48th and Ashland above the Export-Import Gift Shop, owned by Samir Hassan. This mosque was visited by Arab sheiks determined to help the first Muslim settlers build their own mosque. In May 1976, the author covered the arrival of the Sheik of al-Sharjah of the United Arab Emirates, Sultan Bin Mohammed al-Qasimi, for *The Middle Eastern Voice* newspaper.

Sheik al-Qasimi arrived at Butler Field on May 3, 1976, and was taken in a caravan of black limousines to the al-Salam mosque on Ashland Avenue where he was greeted by many dignitaries from the Arab and Muslim community, including heavyweight champion Mohammed Ali and Wallace D. Muhammed of the Nation of Islam. The following day, the Arab and Muslim community hosted a reception for Sheik al-Qasimi. One of Ali's bodyguards was a Beitunia Palestinian from the Hasan clan. His sister Saluka Hasan was a friend of the author's mother. The sheik reportedly donated several hundred thousand dollars toward a fund to build a permanent mosque building in Chicago.

Sheik al-Qasimi arrived to a boisterous welcome organized by the Arab American community in conjunction with the *Bilalian Newspaper* (Mohammed Speaks), the publication of the black Muslims in Chicago. The event was organized by an Egyptian American named Samir Hassan, who operated the Export-Import Gift Shop in the early 1970s and hosted the al-Salam Mosque on the second floor of his business, which was the reason for al-Qasimi's visit. (*below*) The sheik is pictured walking through the crowd.

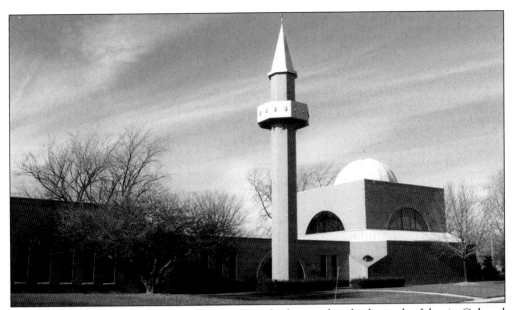

One of the most stunning sights driving through the north suburbs is the Islamic Cultural Center on Pfingston Road in Northbrook. The beautiful minaret towers above the mosque and overlooks a wealthy, upper-class suburban residential community. Imam Kamil Avdich (pictured below teaching a class in 1975) scooped up the first shovel of dirt from the soil from the lot at 1810 North Pfingston Road on September 8, 1974. From humble beginnings of a weekend school and six classrooms, a library, social hall, and nursery room, the ICC now includes a prayer hall that accommodates 500 people, an auditorium that seats 200, and the only minaret in the state of Illinois. The Bosnian community, which launched the mosque in 1974, joined with other Muslim communities including those from the Arab world. But the roots of the ICC begins long before that historic date when the ground was broken and construction began in 1974. The ICC began as an extension of the Islamic center that was located on 1800 North Halsted Street, which was founded in the late 1950s by the Bosnian American Cultural Association (BACA). BACA was formed in 1906 when a group of Bosnian immigrants chartered the organization to represent their interests. A small weekend school was established at 1800 S. Halsted Street in the 1950s as the community grew, and Muslims from other countries also joined. It was founded in 1954.

Over the last 20 years, the south and southwest suburbs of Chicago have seen a steady increase in Muslim immigration. In 2001, about 70,000 Muslims resided in the area, according to a study conducted by Ilyas ba-Yunus, professor emeritus of sociology at the State University of New York. That number continues to rise by about two and a half percent a year.

The Islamic Community Center was founded by Bosnian and Arab Muslims who joined together to provide a solid religious education for their member families and children, in much the same way as other parochial schools that are Catholic, Lutheran, and Jewish, for example. Above is a photograph taken in 1975 of one of the teachers of a class on Islamic studies. Imam Advich passed away in late 1979. He was succeeded by Dr. Rafiq Diab, who served until May 1981. Diab was succeeded by Mustafa Ceric, a native of the town of Grachanica, Bosnia-Hercegovina in what was a part of the former Yugoslavia. In 1986, Imam Ceric departed the ICC, and he was succeeded by Ekrem Mujezinoic in November 1987. In 1989, Imam Senad Agic succeeded Mujezinovic as Imam. Imam Agic came from Bosnia. He graduated from the University of Sarajevo. There he studied Arabic, Persian, and Turkish languages along with literature and Islamic history. Below is a class photograph of students who attended the Islamic Cultural Center school in 1975–76.

Talat Othman immigrated from Beitunia, Palestine, with his father and two brothers in 1947 at the age of 11. His mother, another brother, and his family followed in 1950. He attended Northwestern University and joined Harris Bank in 1956, heading several international monetary departments for the bank. The picture at right was taken in 1976, two years before he left to become general manager of the Saudi Arab Finance Corporation in Paris. Talat served on the Dean's Council of the Kennedy School of Government at Harvard University, on the Board of Directors of the Kahlil Gibran Centennial Foundation, and on the

Board of Governors of St. Jude Children's Research Hospital, chairing its fundraising arm, ALSAC. Talat is married, has three sons, one daughter, and ten grandchildren. He wrote, "I believe firmly that people who benefit from a society should contribute to that society for the benefit of others. One should never forget their heritage." (*below left*) Talat poses with U.S. House Speaker Dennis Hastert. (*below right*) Talat is seen in this photograph with Mayor Richard M. Daley.

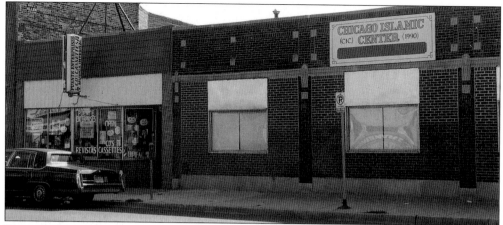

There are many mosques in the Chicagoland area, including several that are based at storefront locations such as this popular center, the Chicago Islamic Center on west 63rd Street in Chicago. Muslims believe in Islam, which means "peace" in Arabic. The Islamic teachings are recorded in the *Qu'ran* (Muslim bible). Mohammed is the prophet of Islam. But Muslims also look upon the prophets of Christianity and Judaism as Muslim prophets, too, such as Abraham, Moses, and Jesus. Muslims pray five times each day. Some Muslim women wear a scarf that covers their head called a "hijab," although many who dress more modernly do not. Recent acts of terrorism, such as those of September 11, 2001, have tended to distort the true meaning of Islam and the Muslim community, causing them to be targets of bigotry and discrimination.

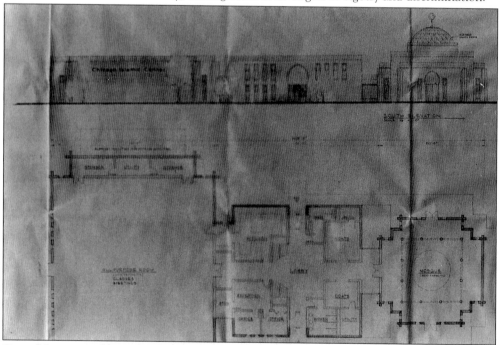

One of the most publicized mosques in Chicago is the Bridgeview Mosque, which is an all-Arab mosque. The photograph is of the original blueprints for its construction. In the fall of 1981, just in time for Ramadan, the holiest month of the Muslim calendar, the mosque opened its doors. It was a modest building, white brick with a copper dome and a prayer hall facing Mecca, surrounded mostly by empty fields.

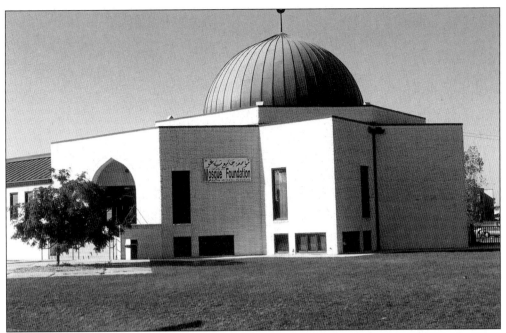

The Bridgeview Mosque today is in a complex of buildings that includes, across the parking lot, the al-Aqsa School and the Universal School. Many Muslims have moved into the area around the mosque and have some of the most beautiful and expensive homes in the community. Sheik Zayid, who was the original Imam, was replaced soon after the building was completed, and a new board of directors called the Mosque Foundation now govern mosque activities and policies.

The current Imam, Jamal Said, is seen in this photograph taken in September 2000 during a voter registration and rally for Arab and non-Arab candidates.

Leaders of several Orthodox and Maronite Christian churches gathered for joint services in this photograph taken in 1975. They include (from left) Rt. Rev. Antoun Khouri; Msgr. S. Haddad; metropolitan Philip Saliba; the Rt. Rev. Anasthasios Emmert of St. George Church; Al Joseph, a longtime owner of Hunter Publishing and Christian Lebanese American philanthropist; and the Rev. James Meena.

Al Joseph, former president of Hunter Publishing and a major philanthropist who has raised funds for St. Jude's Children's Hospital and numerous Churches including Our Lady of Lebanon and St. George Church, is pictured below with his wife Rosemay and former Illinois Gov. James Edgar at a St. Jude's function in May 1998. (Photograph courtesy Talat Othman.)

St. George Church was founded with the help of many community leaders by Fr. Anthony Gabriel, who was American-born Lebanese. In 1967, the group purchased a church building that the Lutheran Diocese had closed and wanted to sell on Humphrey Street in Oak Park. There, they held services for parishioners of Greek, Lebanese, and Syrian heritage. The Lutheran Bishop reportedly was very excited because he had been trying to sell the property for many years. Following the Arab-Israeli war in 1967, thousands of Arab Palestinians and Jordanians began arriving in Chicago. It grew so fast that in 1971, St. George Church in Oak Park hosted the national Archdiocesan Convention. Amazingly, 28 years later, the congregation had increased in size 100 fold, and it again hosted the convention in 1999 with participants coming from most of the country's now 227 orthodox parishes. In 1974, the first pastor, Fr. Anthony Gabriel, was transferred to

Washington, D.C. He was succeeded by Father Emmert, a convert to the orthodox faith from the Lutheran Church. It was during Father Emmert's tenure that the congregation sold the church in Oak Park and in 1985 purchased its present site in Cicero, at 1220 S. 60th Court. The building they bought was originally a Korean Presbyterian Church. Father Emmert served until 1986, when Fr. Nicholas Dahdal was named parish priest. One of the largest Christian orthodox churches is St. George Antiochian Orthodox located in Cicero, Illinois. Pictured at the entrance of the church is Father Dahdal, who is from Taybeh, Palestine. Below is a photograph of a golf outing hosted by St. George Church in August 2000.

Pope Shenouda III, leader of the world's Coptic Orthodox Christian Church based in Egypt, consecrated St. Mark's Orthodox Church in Burr Ridge and St. Mary's Orthodox Church in Palatine during a tour of the United States that took him through Chicago in 2001 before continuing to Los Angeles. His hosts included Egyptian Consul General El-Husseini Abdelwahab and leaders of Chicago's Coptic Orthodox churches. "Pope Shenouda is a tireless advocate of Christian and Muslim relations, and he is the author of more than 100 books," Consul General Abdalwahab said during a luncheon hosted April 30, 2001, at the Executive Plaza Hotel. The Pope said that the Coptic community, which includes more than 10 million Christians in Egypt of the country's 65 million population, began with two churches in the United States. "Today, we have 70 Coptic Churches in the United States and more in Canada," Pope Shenouda said. The first Coptic churches were founded in Jersey City and in Los Angeles. Officials estimate there are about 5,000 Egyptian families in the Chicago area.

Consul General/Ambassador El Husseini Abdelwahab served in Chicago from 2000 until 2004, previously posted at Niger, Washington, and San Fransisco. He is originally from Cairo. His successor as the new Consul General is Amb. Hoda Gouda. Her term expires in 2008. Previously, she served in the former Yugoslavia, in Montreal, and was the head of the cabinet of Dr. Osama el Baz (the political adviser of the Egyptian president Hosni Mubarak).

Talat Othman, a close ally and supporter of many Illinois governors, joins former Illinois Gov. George Ryan in greeting Rev. Samuel Samuel, pastor of St. Mark's Coptic Orthodox Church in Burr Ridge. Governor Ryan is pictured shaking the hand of Rev. Samuel's wife, Mrs. Ebtesam Samuel, during a reception at the Four Seasons Hotel in July 1999.

Christians of all faiths and Muslims often join together to rally in support of peace. Members of the interfaith Arab Americans for Peace and Justice, who hosted a joint Ramadan (Muslims fasting holiday usually held in the late fall and early winter) and Christmas exhibit at the State of Illinois Building downtown. Pictured are, from left, Pat Michalski, director of Ethnic Affairs for former Gov. George Ryan (she also worked for Gov. Jim Edgar and the late Mayor Harold Washington), insurance broker Andy Hassan, Fr. Nicholas Dahdal, Beitunia Club president and realtor Kayyad Hassan, his wife Dorothy Hassan, president of the Chicago Chapter of the American Arab Anti-Discrimination Committee Dr. Shafiq Budron, and activist Summer Rabadi. (Both photographs courtesy of Pat Michalski and Gov. George Ryan.)

Pictured at this typical Palestinian American wedding in 1978 are the following, from left: (back row) Mustafa and Peggy, Mohammed and Kathleen, Naila Nafeza Zaida, and Joan holding her son Matthew; (front row) groom Ahmed Maaz Hassan and bride Suriah, Ahmed's mother Lamia (with Ahmad's niece Marcy in front), Ahmad's father Maaz Mustafa Hassan Zaida, and Nafez (Joan's husband). The photograph shows how Americanized most Arab Americans are in merging customs. This family comes from the Zaida tribe from Beitunia. But, Arabs define their lineage through their sons and their sons' names. The father Maaz Mustafa Hassan Zaida is actually Maaz son of Mustafa son of Hassan of the Zaida tribe. (There are about a dozen tribes, or Hamoulahs in Arabic, that settled in Beitunia and that include Shaheen and Hairaish.) Oftentimes, when passing through customs, immigration officers simply trimmed the names to reflect American customs and Maaz Mustafa Hassan Zaida would simply become Maaz Mustafa Hassan. (Photograph courtesy of Andy Hassan.)

One of the area's foremost Islamic scholars is author and professor Dr. Assad Bussool, who poses in his offices at the American Islamic College, 640 W. Irving Park Road. This picture was taken in May 2001, for a profile for the *Arab American View* newspaper. The AIC was established in 1981 as a private, not-for-profit, four-year institution. American Islamic College is situated about four miles north of downtown Chicago on three and a half acres of land overlooking beautiful Lake Michigan. The main building is an architectural landmark designed by Barry Byrne (one of the four best-known students of the highly esteemed architect Frank Lloyd Wright) and built in 1921 and has been placed on the National Register.

Ceremony is very important in Christian and Muslim wedding tradition. The brides would decorate their hands, faces, and feet with henna, a dye that eventually wears off after time. Pictured above is a Palestinian woman performing a henna dance in celebration of a traditional pre-wedding ceremony.

Father Dahdal follows the party of a wedding he performed for groom Ray Damarjian and bride Claudia. Ray's family is Palestinian Armenian from Bethlehem, Palestine. The wedding ceremony took place at St. George Antiochian Church in Cicero in November 2000, and the reception was held in Oak Lawn.

Pictured here at the Haleem family wedding on July 19, 1966, are the following, from left: (back row) Joseph Haleem, Nadra Haleem, Waheed Haleem, Mary Haleem, Wadia Haleem, patriarch Hassan Haleem, bride Ferdos Haleem, groom Abbas Haleem, Abed Haleem, Raefa Haleem Khalil, Fatima Haleem, and Mohamed Haleem; (second row) Raji Haleem, Sophia Haleem, Ahmad Haleem, Huda Haleem, Neil Haleem, and Sammia Haleem; and (front row) Mofeed Haleem, Adel Haleem, Deeb Haleem, and Reyad Haleem.

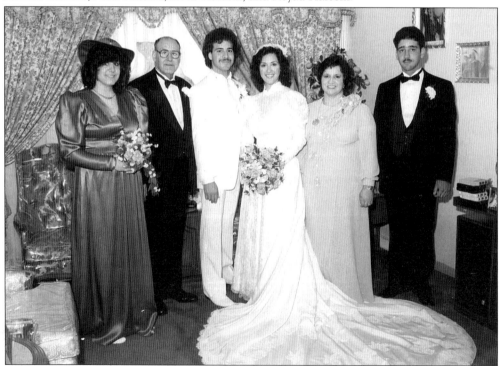

An April 21, 1984, wedding portrait shows, from left, Naela Haleem, Yousif "Joe" Haleem, groom Ahmad Haleem and bride Huda Haleem, Nadra Haleem, and son Neil Haleem. (Photographs courtesy of Neil Haleem.)

The vast majority of Arabs elected to public office around the country are of Lebanese heritage, in part because they are predominantly Christian and easily assimilated into American society. To name just a few, they include U.S. Sens. James Abourezek, James Abnor, George Mitchell, and John Sununu; Govs. Victor Atiyeh and Jean Shaheen; and U.S. Congressmen Mary Rose Oakar, Nick Rahall, Ray LaHood, Darrell Issa, and Toby Moffett. Most Arabs of other nationalities have served in local and regional elective offices as municipal trustees, legislators, local park and school boards members, and as convention delegates.

The ease of Lebanese assimilation was also hastened by their growing presence in Hollywood and particularly by the popularity of one show, *Make Room for Daddy*, hosted by Lebanese American actor Danny Thomas. He later had another popular show called *The Danny Thomas Show*. His "Uncle Tannous" (played by Hans Conried) portrayed the positive aspects of Arab world culture during the programs. Other actors and actresses of Lebanese heritage include Kathy Najimi (*Sister Act*), Tony Shalhoub (*Monk*), Victor Taybeck (*Alice*), Kristie McNichols, Michael Nouri, Selma Hayek, and producer Mario Kassar.

But while they have not held many elective positions, Arab Americans remain active and engaged at all levels of the American political process. More and more Arab Americans of all nationalities are also entering the entertainment field.

The late Mayor Richard J. Daley accepts a gift in August 1976 from the ambassador of Morocco. The late Col. Jack Riley is pictured behind Daley, and the Moroccan Tourist Chicago Office director Baker Lemseffer is pictured in the center. The photograph was taken by the author in Mayor Daley's office. Hanania conducted a lengthy interview with Daley that was later published in the *Middle Eastern Voice* newspaper about the importance of ethnic communities to Chicago, including the growing Arab American community.

Dr. Ghada Talhami served as the Chicago director of the Arab Leagues in the 1970s and is pictured here with an Arab League official. She is currently a professor at Lake Forest College in the Department of Politics. She earned her Ph.D. in African History from the University of Illinois Chicago. Dr. Talhami has authored many books, including *Palestinian Refugees: Pawns to Political Actors*. She has received many awards including a Fulbright Senior Scholar Award in 1997 and the Trustee Award for Teaching Excellence and Campus Leadership at Lake Forest College, 1994.

Joe Bou-Sliman was born in Pittsburgh in April 1931. His grandfather came to America in the 1848 from Zahleh, Lebanon, and the family lived in Toledo, Cleveland, Boston, and Pittsburgh and migrated to Chicago in 1962. Bou-Sliman served in the U.S. Marines and became the first Arab American to serve as a special agent in the FBI. Later, he served as police chief in the Chicago suburbs of Villa Park and Hickory Hills. An author, Bou-Sliman is a member of St. John the Baptist Church in Northlake. He is most often quoted saying, "The Lebanese were among the first to discover and settle in North America, before Columbus and before Leif Erickson."

The Arab American Congress for Palestine hosted many meetings in which Middle East leaders, journalists, and activists would speak to the Palestinian and Arab American community about Middle East events. Above is activist Dr. Emile Touma, Nazareth Mayor Tewfiq Zayyad, and Ayoub Talhami, one of the leaders of the AACP. This picture was taken at the Middle East Club banquet hall at 5448 S. Damen Avenue on October 10, 1976.

The somewhat blurry picture was taken during the same event and shows the cramped environment in which many early meetings were conducted. At the time, many Arab Americans were being hassled by the FBI, including the author. The FBI maintained reports on their activities. The report on the author Ray Hanania is 45 pages in length and was opened the week he was honorably discharged from service in the U.S. Air Force during the Vietnam War. Most federal probes were driven by lack of knowledge, hysteria, and information based on stereotypes rather than on facts.

One of the spiritual leaders of Palestinian political activism is the late Prof. Ibrahim Abu-Lughod, a renowned professor of political studies at Northwestern University and once adviser to the Palestine Liberation Organization, which helped to convince Palestinian Pres. Yasser Arafat to negotiate a peace accord with Israel. Abu-Lughod played a key role in bringing activists to Chicago, including Clovis Maksoud, who was, at the time of this photograph in 1976, ambassador of the Arab League based in Washington, D.C.

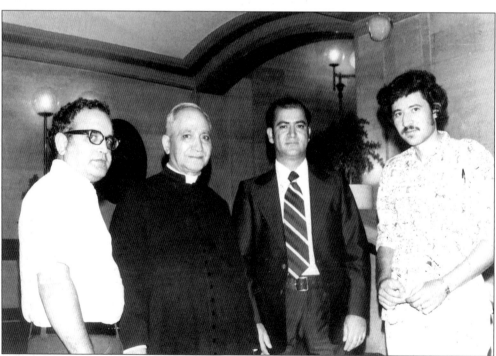

Pictured here are activist Rafat Rabi and the late Rev. Ibrahim Ayyad; Taki Kalla, AACP president and director of the weekly *Voice of Palestine Radio* show based in Chicago; and activist Ziad Dajani. This was taken during a conference at the Midland Hotel on September 12, 1976.

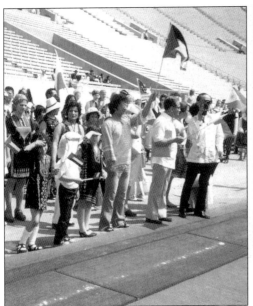
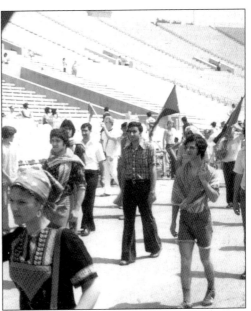

(*above, left and right*) Palestinians participate in Chicago's Annual International Day Festival at Soldier Field in July 1976. Despite the large concentration of Palestinian Muslims and Christians in Chicago, the city tried to prevent attendees from waving Palestinian flags. But, the group persisted and joined a thousand other representatives of several dozen of the city's ethnic and religious communities in showcasing their heritage. (*below*) Middle East politics were often very passionate and controversial. Student members of the Organization of Arab Students at the University of Illinois at Circle Campus protest on Palestine Day, May 14, 1976. The administration at Circle Campus was often criticized for anti-Arab policies, showing favoritism to Jewish American and pro-Israel student organizations while prohibiting Palestinian or Arab events. The university often refused to provide funding allocated for student events when speakers were Arab or supportive of the Palestinian cause. Yet thousands of Arab students graduated from Circle. The author, Ray Hanania, was a reporter for the university's newspaper, *The Daily Illini*, and served on the Student Senate for two years.

On May 16, 1976, author Ray Hanania (far left) joins a panel hosted by the Arab American University Graduates exploring the challenges of journalism. Pictured are Khalil Jahshan, who later became president of the National Association of Arab Americans and now works with the ADC, and far right, Prof. Husni Haddad, who taught for many years at St. Xavier University on Chicago's Southwest Side. Today, the college has a large study named in his honor and has a large Arab and Muslim student body and Middle East studies department.

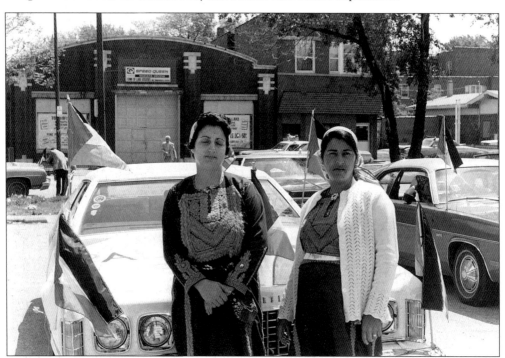

On May 10, 1977, in Marquette Park, two women dressed in traditional Palestinian embroidered dresses wait for a Palestine Day caravan to begin. The caravan consisted of more than 30 vehicles that paraded through the streets of Chicago flying Palestinian flags.

Egyptian American Prof. M. Cherif Bassiouni serves as president of DePaul's International Human Rights Law Institute, the International Institute of Higher Studies in Criminal Sciences in Siracusa, Italy, and the International Association of Penal Law in Paris, France. In 1992, he was appointed a member, and later chairman, of the U.N. Commission to Investigate Violations of International Humanitarian Law in the former Yugoslavia. From 1995–1998, he was elected vice chairman of the U.N. General Assembly's Committee for the Establishment of an International Criminal Court, and in 1998, he was elected chairman of the Drafting Committee of the U.N. Diplomatic Conference on the Establishment of an International Criminal Court. In 1999, he was appointed by the U.N. Commission on Human Rights as special rapporteur on the right to restitution, compensation, and rehabilitation for victims of gross violations of human rights and fundamental freedoms. Professor Bassiouni is the author and editor of 63 books and 210 law review articles published in Arabic, English, French, German, Italian, and Spanish. In 1999, he was nominated for the Nobel Peace Prize for his lifelong work to establish an International Criminal Court.

This picture was taken at the reception for the opening of the King Tut Exhibit at the Museum of Natural History, April 14, 1977, hosted by the MidAmerica Arab Chamber of Commerce.

Two people who are not Arab but who deserve much recognition for their dedication to promotion of Arab American cultural activities are Grazi Figi (above) and Pat Michalski (below, back row). Figi is pictured in August, 1976. She was sales manager for Middle East Airlines (1971–1976), area manager for Royal Jordanian Airlines (1977–1982), a member of NGOs based in Cairo, Bordeaux, and Jakarta (1983–1987), and deputy executive director of the Mid-America-Arab Chamber of Commerce (1987–1991). From 1991–2001, she was senior vice president/managing director of the Mid-America Committee for International Business. After spending a year studying in Istanbul, she has been a private consultant specializing in the Arab/Islamic world and Southeast Asia. She held local and national offices for the United Holy Land Fund, the Arab-American University Graduates, and the Chicago-Casablanca Sister City Committee, and produced world music concerts for Hamza El Din, Anouar Brahem, and Cheb Tati.

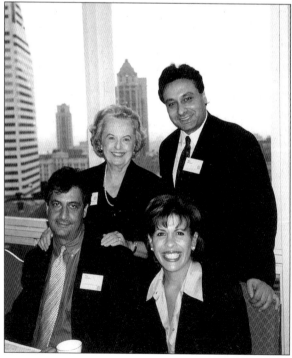

Pat Michalski helped organize many events including this one in August 2001 honoring NBC journalist Hoda Kotbe (Egyptian American, seated right) and former CLTV reporter and anchor Mike Monseur (standing back row), with the author Ray Hanania. She became acquainted with the Arab American business community as manager of sales for Parker House Sausage at 46th and State Street. Her knowledge of ethnic and religious communities through her contacts won her a job as a communications deputy to the late Mayor Harold Washington under press secretary Alton Miller, and later for Mayors Eugene Sawyer and Richard M. Daley, and Governors Jim Edgar and George Ryan. Pat and her husband Harry have three children of their own but also adopted three other children of mixed races.

Two community leaders, Amna "Anna" Mustafa and Fadwa Maali Naji, pose together in May 2000. Mustafa served as the very first Arab American member of the Chicago Board of Education and worked for the civil rights of all ethnic groups in Chicago and as a part of the 2000 Federal Census. After September 11th, as Mustafa was trying to return to Beitunia, Palestine, to attend the death of her father, she was harassed and detained at O'Hare International Airport by overzealous airline employees. Despite the hassles, Mustafa fought back and won several court actions against the airlines and the Chicago Police Department for unlawful arrest. Fadwa Maali Naji is a longtime activist for women's rights in Chicago and the president of Salam Travel Agency. She immigrated to the United States in 1961.

Naji's late husband, Mahmoud Naji, who was national president of the United Holy Land Fund (not the Holy Land Foundation, which was shut down by federal authorities after September 11th) is pictured here. The UHLF is one of the nation's most reputable and effective charitable organizations, raising funds to ease humanitarian needs across the Middle East and especially in Palestine. Naji (at the podium) speaks at an event hosted by the Arab American university graduates. Clovis Maksoud is seated on his right, and longtime activist and Professor Mary al-Azzawi is seated on his left.

73

Members of the American Arab Anti-Discrimination Board pose following a meeting with former Gov. Jim Edgar in 1998. Among those pictured are Issam Zeitoun, president (second from left); Edgar (center); activist filmmaker Janie Khoury, who also served as a member of the Illinois Advisory Committee to the U.S. Commission on Civil Rights (third from right); and the author Ray Hanania (far right).

Members of the National Arab American Journalists Association, Chicago Chapter, and community leaders meet with Cook County Treasurer Maria Pappas May 2001. Pictured are Amna "Anna" Mustafa (front left); radio talk show host Yousef Shebli; Nareman Taha and Itedal Shalabi of Arab American Family Services (Palos Hills) Pappas; and restaurant owner and then bank officer Wally Aiyash (far right).

Mayor Washington created the Arab Advisory Commission, which helps to address issues of discrimination and to promote cultural awareness. Pictured is the board in October 2000, from left: Diane Kakish, Mohana Shawahin, Nidal Rabie, Director Sahar Mawlawi, Chairman Marwan Amarin, Noor Sweiss Michael, and second from right Andy Hassan, and far right Saida Callahan. The committee helps plan the annual Arab Heritage Month activities every November.

Pictured here are former CLTV reporter and anchor Mike Monseur with ADC Chairman Dr. Shafiq Budron and longtime ADC activist and Arab American businessman Ali Ata. After leaving CLTV, Monseur later became a spokesman for IDOT.

Rouhy J. Shalabi, the first Arab American to serve on the Chicago Park District, was appointed on June 19, 2002. An attorney who practices with his two brother Riyad and Adlai, Shalabi previously served as the first president of the City of Chicago Advisory Council on Arab Affairs. He also serves as a member of the Circuit Court of Cook County's Racial and Ethnic Committee, the Cook County State Attorney's Hate Crimes Commission, and the Multi-Cultural Advisory Council. He is president of the Stevenson Local School Council and has served as president of the Arab-American Bar Association. Shalabi is married to Samar Shalabi, and they have eight children. (Photograph courtesy of Rouhy J. Shalabi.)

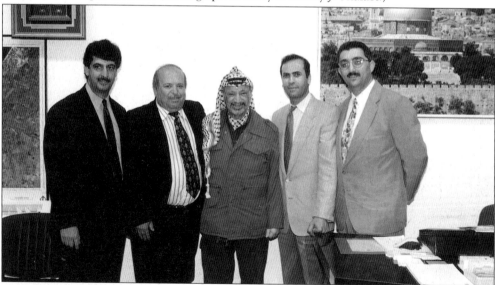

Author Ray Hanania, serving as national president of the Palestinian American Congress, joins fellow board members Adnan Salah, Palestinian President Yasser Arafat, Vice President Fuad Ateyah, and attorney and Chicago Chapter PAC President Fadi Zanayed in Gaza, Palestine, in 1995.

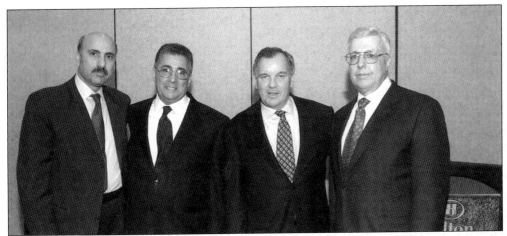

The Supreme Court of Illinois appointed William J. Haddad (second from left) a judge in the Circuit Court of Cook County from January 16, 2003, to December 6, 2004. Justice Haddad has been an attorney for nearly 30 years, served as an assistant state attorney in Cook County, and is a founder and past president of the AABA of Illinois. Haddad's father emigrated from Lebanon. Members of his family helped entertainer Danny Thomas establish the St. Jude Children's Research Hospital. Haddad was instrumental in winning a settlement from a major international hotel chain that denied public accommodations to the Midwest Federation of Syrian-Lebanon Clubs on the date of the September 11th attacks. Haddad received his law degree from DePaul University in 1973, worked as an assistant state attorney from 1974 to 1981, and started his own private practice, currently known as Haddad, Schlack & Associates. He served on Gov. Rod Blagojevich's transition team. Justice Haddad and his wife, Sandy, have two children, Christina and William Jr. Pictured with Judge Haddad are businessman and investor Antoine "Tony" Rezko, Mayor Daley, and Talat Othman. Rezko is a longtime community activist who has supported many elected officials including County Board President John Stroger, Mayor Daley, and Gov. Rod Blagojevich as well as Arab Americans seeking election to public office. (Photograph courtesy Talat Othman.)

Rezko, a partner in Rezmar Builders, owns several food franchises in the Chicago area. Here he is pictured in March 1999 with County Board President John Stroger and Talat Othman at a dinner hosted by ABPA honoring Rezko and Stroger. (Photograph courtesy Talat Othman.)

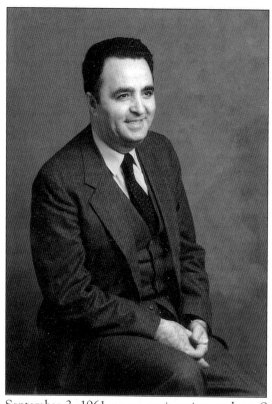

Salameh Zanayed is the retired founding director of the Chicago Arab Advisory Commission. He was a longtime radio talk show host and served as national president of the American Federation of Ramallah.

Zanayed arrived in Chicago on September 2, 1961, as an engineering student. Salameh married his sweetheart, Nadia, and worked as an accountant with the Brunswick Corporation until 1969 when he opened Amana Certified with his brother, Khalil at 3939 N. Ashland. A year later, he opened Jett Travel. On September 9, 1991, Salameh became the first Arab American to host an Arab TV show.

"It was called the *Voice of the Middle East.* It was on Channel 26, and the host was Assyrian leader Klamis Ganji. Later we sold it to Issa Tadros. On May 1, 1985, the two Arabic radio stations closed, including the *Voice of Palestine,* and one by Tobia Hachem," he recalls. "When the two radio stations closed, I decided to open my own radio program on May 1, 1985, and I kept it through 1994. It was very successful. In 1994, I turned it over to Yousef Shebli, who now is the host."

With the change over of the radio show, Salameh did not lose his interest in launching a professional Arab American television program, and he again launched another television show called *Good Evening Chicago* (Mesall Khair Chicago). Salameh also published a book of his poetry called *The Birth of the Dawn.* Nationally, Salameh served as the national president of the Ramallah Federation, which is the largest Palestinian American organization in the United States. He also served as a past president of St. George Church, now located in Cicero and one of the largest Christian Orthodox Arab American churches in Chicagoland. It is headed by Father Nicholas Dahdal. And he was involved as chairman of the board of directors of the Phoenician Club, which named him Man of the Year in 1985.

His most influential position in terms of helping Arab Americans was his role and involvement in getting Mayor Washington to establish the Arab Advisory Commission. Eventually, working with dozens of other Arab American leaders in Chicago, the Arab Advisory Commission was created and Salameh was selected as its first director and community liaison. With Salameh's help, Mayor Daley launched the annual reception to honor Chicago's Arab American community. It is the first time a major elected official has recognized our community, and Mayor Daley's role has opened many doors that were previously closed.

Judge Sam J. Betar III, 44, joined the bench as a Cook County associate judge in 1998 following his selection by Circuit Court judges. Betar (right) is photographed with Arab American journalist and writer Ali Al Arabi (left). Betar was assigned to the Daley Center handling a high volume call involving post-judgment collection proceedings. Betar's introduction to the law came at an early age through his late father, Samuel J. Betar II, an esteemed former federal prosecutor who died in 1999. Betar and his five siblings, including his brother Michael, a local attorney, grew up in the northern suburbs. After graduating from Loyola Academy in Wilmette, Betar attended Boston College. He graduated from the Loyola University School of Law in 1983. Betar joined the Oak Brook firm of Botti, Marinaccio & DeLongis Ltd., where he handled civil and criminal litigation. In 1986, Betar became an associate with the Lincolnwood firm of Kamensky & Rubenstein, where he handled criminal matters for five years. Betar joined the Chicago firm of Arnold and Kadjan in 1991 until becoming a jurist. Sam's wife is Margaret and they have three children. (Information excerpted from a profile originally published by the *Chicago Daily Law Bulletin* on May 16, 2001. Reprinted with permission.)

Former chairman of First Chicago Corp. and First National Bank, A. Robert Abboud (second from left) is pictured with Marshall Bennett, Fr. Don Senior, and Talat Othman in September 2004. A Korean War veteran whose ancestors hail from Lebanon, Abboud received the Bronze Star and a Purple Heart. A Harvard Law School graduate, Abboud was born in 1929. (Photograph Courtesy Talat Othman.)

Frank Isa is a Chicago fireman and the former president of the United Holy Land Fund (2001), the region's leading fundraising organization for the Arab community. Isa is married to Ola, who was instrumental in getting Isa involved in the UHLF and in many community activities. They have two children, Muna, 15, who attends Aqsa school, and Musa, 9, who attends the Universal School. Isa has served as vice president on the 1999–2000 board and has been with UHLF as an activist for more than five years. He was instrumental in launching the UHLF annual golf outing, which tapped new sources of funding in the past years. The UHLF has offices at 79th and Austin in Burbank. Isa also serves as the chairman of the fundraising committee for Aqsa school.

Kayyad "Edward" Hassan is a realtor in the Southwest suburbs and the president of the Beitunia American Club. He is an active board member of several Arab American organizations, including the Arab American Veterans Association of Chicago, and has been an organizer and supporter of many community events. Pat Michalski, director of Ethnic Affairs for several Illinois governors, presents a certificate to Hassan for his many contributions to the state's ethnic communities. Kayyad is pictured with one of his sons. Kayyad's father, Ali Hassan, came to America in 1955 mainly to find a better life. A few years later in 1960, Kayyad followed, and today he manages one of the largest real estate management companies in the Southwest suburbs, Edwards Realty in Palos Heights.

Hasan M. El-Khatib is the CEO and founder of the DENA Corporation based in Elk Grove Village. DENA was founded on March 7, 1968, by Hasan El Khatib, an experienced chemist with a master's degree from Roosevelt University. Using his skills and dedication to the skin care, hair care, and health care industry, Hasan transformed his initial $1,000 investment along with a production line that began at his home in offices set up in his garage, into a multi-million corporation that manufactures and distributes skin care, hair care, and health care products under the now popular DENA logo with 24 popular registered trademarks. In 1976, DENA developed Meta Henna Creme, a pre-mixed ready-to-use hair coloring product line. This was a unique and innovative product concept.

In his field, Dr. Wafik Hanna is a member of many societies, including the American Academy of Cosmetic Surgery, the American Academy of Facial Plastic and Reconstructive Surgery, the American Medical Association, and the American College of Surgeons. Dr. Hanna proudly serves on the staff of Hinsdale, MacNeal, LaGrange, and Good Samaritan Hospitals. Dr. Hanna is a pioneer and is well-known for performing multiple facial cosmetic procedures in one stage. Because Dr. Hanna specializes exclusively in facial cosmetic surgery, he has done thousands of facelifts, nose jobs, and eye jobs over the years. The results are astounding. As well as being a dynamic and articulate speaker, Dr. Hanna is an author and highly qualified teacher. He has appeared on numerous television and radio programs and has been featured in many publications. Dr. Hanna works meticulously to ensure that each feature compliments the face, enhancing rather than correcting. (Photograph courtesy of Wafik Hanna.)

Egyptian American doctor Hassan Hassouna, and his wife Sharon, are pictured here with their child, Amin, at their Fullerton Street penthouse in 1976.

Vice President Al Gore named Gabe Fakhouri (third from left) as a delegate in his bid for the U.S. presidency in January 2000. Fakhouri, a Democratic Party activist, appeared on the March 21 primary election ballot in the Third Congressional District. The district runs from the 23rd Ward in the city as far south as Palos Heights in the suburbs, including Bridgeview, Burbank, Worth, and parts of Oak Lawn. Fakhouri served as president of the Young Democrats of Illinois from 1995–1997, as National Political Director for the Young Democrats of America, as a member of the Illinois Ethnic Coordinating Committee chaired by Tom Hynes for the Clinton-Gore campaign in 1996, and on the Illinois State Crime Advisory Committee representing Worth township. In 2005, he was the Southwest Side coordinator for Barak Obama. He is pictured here with Mike Monseur (left) and writer Mustafa Owaynot (center).

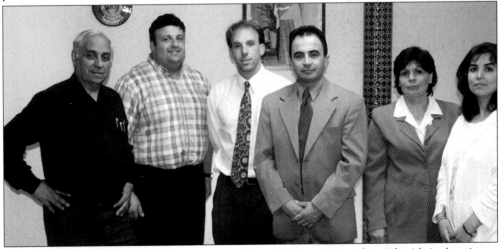

Writer Shafiq al-Khalil, Fakhouri, activist David Nasser, journalist Ali Al-Arabi, Amna "Anna" Mustafa, and Saffiya Shillo are seen here during an election planning meeting for Arab American candidates. Author Ray Hanania was one of the first Arab Americans to run for public office in November 1992 (38th Illinois House District race), followed by several candidates including Miriam Zayed, who ran three times for the District 230 school board. In November 2000, Arab Americans fielded a slate of more than nine candidates for various offices in Chicago who, despite their qualifications, were constantly challenged because of rising anti-Arab bigotry, even before September 11, 2001.

Mayor Sawyer joins Talat Othman (left), president of the American Arab Business and Professional Association (ABPA), and an officer with the American Arab Anti-Discrimination Committee (ADC) in presenting the ADC Outstanding Achievement award to author Ray Hanania in this November 1988 photograph. Fadi Zanayed (far right) is an attorney and former president of the Chicago ADC Chapter, and also the Chicago Chapter of the Palestinian American Congress. Zanayed is also a writer and a poet who published a book of poetry.

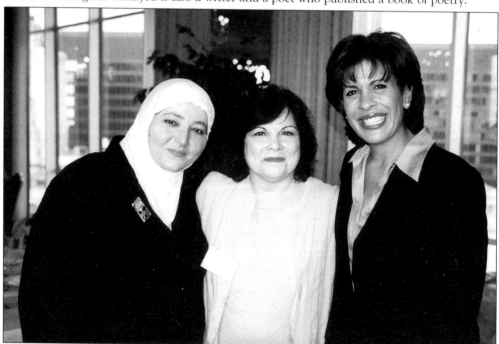

Greek American Mary Diab (center) is an honorary Arab American who has worked hard to promote ethnic affairs for a number of governors and county officials. She is pictured here with poet Sammer Ghouleh and NBC TV reporter Hoda Kotbe.

When it comes to the education of our children we all want the same thing:

"the best education possible"

It all comes down to one important factor:

Which candidate is most qualified to give our children what they need?

And, when it comes to who is <u>most qualified</u> in the District 230 race...

MIRIAM ZAYED

that candidate is

MIRIAM ZAYED

A flyer used in the campaign to elect Miriam Zayed to the District 230 School Board in 1998. District 230 has three high schools and the largest concentration of Arabs in Chicagoland.

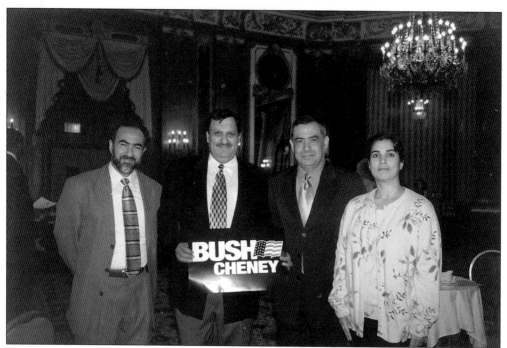

Ossama Jamal, president of the Mosque Foundation joins Ihsan Sweiss, the honorary consul general of the Hashemite Kingdom of Jordan, Jordanian journalist Saad AbuNada, and Saffiya Shillo at a political rally for President Bush in October 2000 at the Condesa Del Mar banquet hall in Oak Lawn.

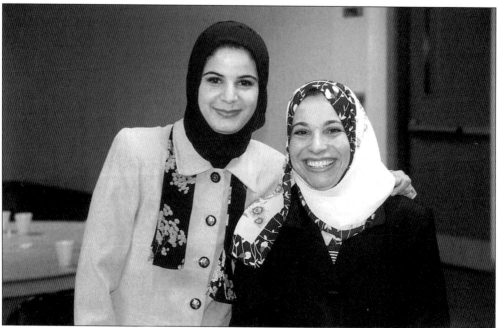

Nareman Taha, who ran for the post in the Burbank School District in November 2000, is a co-founder with Itedal Shalabi of Arab American Family Services, which provides a wide range of social services to the Arab American community, located in Palos Hills.

Arab-Americans For Edgar Committee

Is Proud to Invite You to a

Tribute

to

Governor Jim Edgar

at a Reception/Rally on

October 16, 1994 Nº **2025**

Condesa del Mar

12220 South Cicero Avenue

Alsip, Illinois

5:30 p.m. to 8:00 p.m.

Tickets: $15.00

Hanania

Seen here is one of many receptions held in honor of former Gov. Jim Edgar, who worked closely with Arab Americans to include them in state government programs. Under Edgar, and working with his ethnic affairs director Pat Michalski, Arab Americans were able to broaden their participation in American government and politics.

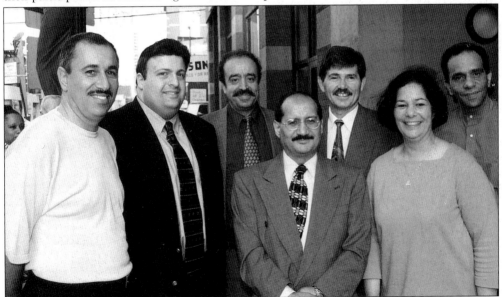

Members of the Arab Democratic Club are Khalil Shalaby, Gabe Fakhoury, Samir Khalil, Saad Malley, former Chicago interim mayor and Cook County clerk David Orr, Miriam Zayed, and Nelson Hanna, the founder and coordinator of the only troop of Arab American Scouts in existence. Hanna's scouts perform flag posting ceremonies at many Arab banquets and events.

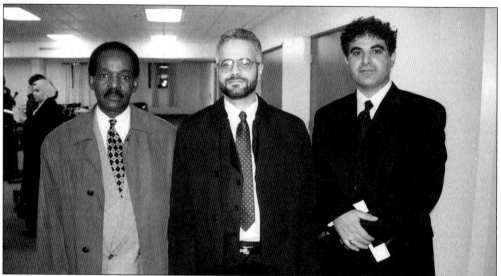

Nick Zeyadeh (center) ran for Cook County sheriff in 2000. He is pictured with his campaign supporters and organizers.

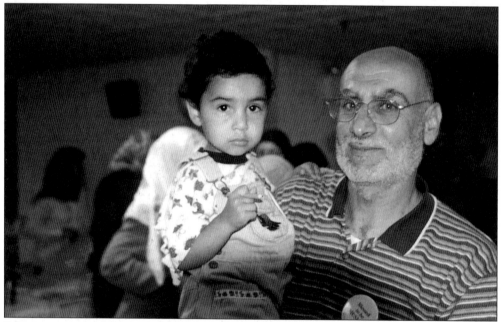

Palestinian activist Mohammed Saleh was arrested and charged in Israel with supporting terrorism and served five years in prison after being forced to sign a confession in Hebrew, a language he could not read. Later, he was targeted by the U.S. government in what community leaders believe is a politically motivated federal terrorism indictment. Although Saleh has denied any involvement in terrorism at all, he has been persecuted by the government because of his beliefs and views on the Palestinian-Israeli conflict. Community leaders have challenged the indictment, arguing that if he were a terrorist, why would Israel have released him? Saleh, who resides in Bridgeview with his wife and children, has been unable to obtain work. His wife and family have been seeking to raise funds for his legal defense. The Saleh case is one of many viewed by Arab Americans as political persecution driven by American policies in support of Israel.

Lebanese American leaders George R. Simon, Michael J. Coury, and Edward Saad are seen here at a meeting of the Phoenician Club of Chicago, May 8, 1976. Coury was then serving as president of the Midwest Federation of Syrian and Lebanese Clubs, which had chapters around the country. All of their meetings begin with the Pledge of Allegiance and the singing of the American National Anthem.

Seen here are Michael J. Coury and Minor George, a Lebanese American business leader who was visiting Chicago from Ohio.

The Midwest Federation of Syrian and Lebanese Clubs and the Phoenician Club always organize the largest golf outings. Pictured above is a foursome and below a threesome who played golf at the federation's 1976 golf outing at Villa Olivia resort in the Western suburbs.

Pictured here are haflis hosted by the Midwest Federation of Syrian and Lebanese Clubs and Phoenician Club after the meetings and the golf outings. The Phoenician Club holds one of the largest haflis, or Arab parties in Chicago, always drawing more than 1,000 party-goers who dance the Debka. The dinners would often attract members of the Palestinian and Jordanian Community and although the MWFSLC were predominantly Christian, many Muslims would also attend. Entertainment would also include an ethnic fashion show, professional Debka troupe, and a Middle East band that played some of the Middle East's most popular Arabian music.

Little has changed in the past 30 years, and the MWFSLC attract the largest attendance at haflis and banquet receptions. These pictures were taken at a Phoenician Club dinner in 2000, with entertainers and singers performing below.

U.S. Representative Ray LaHood, a Lebanese American who represents a Peoria congressional district, is the guest speaker in this photograph. He is being introduced by Fr. Victor Kayrouz.

Former United Holy Land Fund President Abdul S. Manasrah joins Palestinian Ambassador Nasr al-Kidwa and Palestinian American Community Center President Abdel Ghafar al-Arouri. Al-Arouri has dedicated his life to supporting Arab Americans who have sought public office in northern Illinois and championing the civil rights of Arabs, Palestinians, and Muslims.

The Port Said Restaurant at 6245 S. Cicero was one of the more popular Arab American restaurants that drew a diverse Arab clientele of Palestinians, Lebanese, Syrians, Egyptians, Christians, and Muslims. Although many conservative Muslims and some Christians frown on belly dancing and modern Arabian music today, in the 1970s, belly dancing was a very popular dance form. It is still popular in the less restrictive Middle East, especially in Lebanon, Syria, Jordan, Egypt, and Palestine. One of the early restaurant clubs was the Arabian Sands in the 1960s, owned by one of the sons of Hassan Haleem.

In this photograph, Fr. John Naffeh of Our Lady of Lebanon Church joins with parishioners to celebrate his birthday at the Port Said restaurant in 1976.

94

The oud is a mandolin-type instrument with 12 strings that is a key part of Middle Eastern music, usually accompanied by a tabla (drum) and sometimes a keyboard. The Arabian tabla dates back to the Persian drum called the zarb (as is also true for the Turkish darabuka—darabu means "to hit" or "strike" in Arabic). Pictured above is an oud player at the old Sahara Restaurant at 3304 W. Fullerton, and one of the many belly dancers who entertained. Today, one of the truly exciting places to go is Julianna's Restaurant, 3001 W. Peterson, owned by Albert "Ali" Baba, an Assyrian American who speaks and sings in several languages.

One of today's more popular oud masters is George Jubran, who was born in Palestine and later immigrated to Jordan and later Syria where he graduated with a law degree. As a child, he learned to play the accordion, but since the late 1960s, he has mastered the oud and is one of the most popular players to perform at Arabian haflis and events in the Chicago area. Jubran is considered the best oud player in the Midwest.

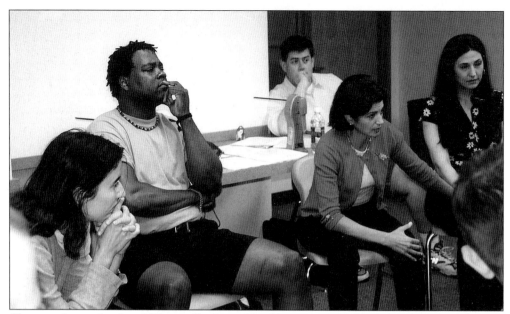

Chicago playwrights Jamil Khoury (back row) and his partner Malik Gilani launched the Silk Road Theatre Project in 2003 to bring Middle Eastern themed plays to Chicago theater. Their first successful play was *Precious Stones*, which included some of the actors and actresses in this picture taken in 2001, from left, Bettina Roujos, Robert Hines, filmmaker and actress Janie Khoury, (no relation to Jamil), and Roxane Assaf, an actress and accomplished journalist honored by the National Society of Professional Journalists in 2004. (Photograph courtesy of Jamil Khoury.)

Governor Ryan presents an award to another entertainment venture called Genesis at the Crossroads, which brings Arab, Persian, and Jewish musical performances to the stage every year. Pictured here in January 2000, when it was first launched, are advisory board members, from left, Hanan Zayid (sister of Miraim Zayed), Gashi Khadavi, Mandana Brown, Robert Khoury (co-founder), Governor Ryan, Wendy Sternberg (co-founder), Mitchell Pawelan, Miriam Zayed, and the author Ray Hanania. (Photograph courtesy Pat Michalski.)

To celebrate Arab Heritage Month in November 1999, author Ray Hanania produced an extensive exhibit of 38 photographs and captions defining the Arab American history in Chicago. Pictured above, community leaders join Governor Ryan in celebrating the opening of the display at the State of Illinois Building, which was the first of its kind and ran every year until 2003. Some of those pictured are, from left (front row), Saad Malley, Kayyad "Edward" Hassan, Um Zayed, Governor Ryan, Fadwa Hasan, Dr. Ghada Talhami, Miriam Zayed, and Talat Othman. (*below, left*) Activist Anaed Samad, daughter of Chicago writer Fahmi Samad, is seen here after giving a presentation to the community about her trip to Palestine in 1976. Fahmi Samad was one of the first Arab Americans to write a regular column for a Chicago newspaper, *The Independent Bulletin*. (*below, right*) Pictured here on May 16, 1976, is Suheil Nammari, a successful engineer and activist with the *Voice of Palestine Radio* the Arab American Congress for Palestine, and later as a supporter of many candidates for public office.

Golfers are pictured here at the United Holy Land Fund's July 2001 fundraiser at the Silver Lakes Country Club in Orland Park, a suburb with a growing Arab American community.

Nareman Taha, Lyla Ismael, Hoda Kotbe, and Itedal Shalabi are pictured here at a dinner honoring the NBC television journalist. Taha and Shalabi are the partners in Arab American Family Services, which is based in Palos Hills and provides social services to the Arab and Muslim community addressing a growing array of social problems that include many common to all communities, such as domestic abuse, neglect, welfare, senior citizen assistance, and more. Arab American Family Services works with many city, county, and state agencies to provide assistance to those in need, including to the Arab and Muslim American community, which has become a major focus of community need.

Arab American Family Services conducts seminars, training, and programs both for Arab and Muslim American community groups and for American government and business organizations to raise awareness of the social challenges that exist and the many services that are available. Arab American doctors and medical practitioners participate in a community health fair co-hosted by the Arab American Medical Association in April 2001.

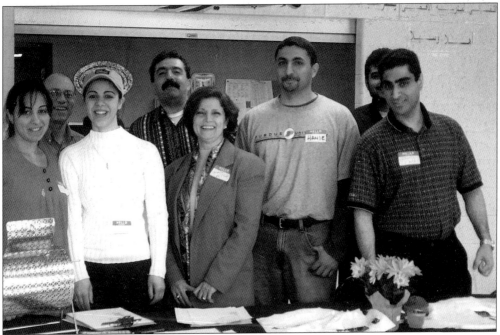

Pictured here are more of the volunteers at the health fair who provided information and services to the hundreds of attendees. (Photographs courtesy of Arab American Family Services.)

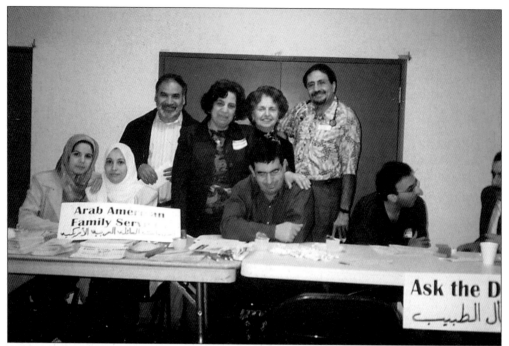

Arab American Family Services co-directors Nareman Taha and Itedal Shalabi are seated on the left at the "Ask the Doctor" table at the community health fair they helped organize with the members of the Arab American Medical Association. (Photographs courtesy of Arab American Family Services.)

Members of the Arab American Association of Engineers, headed by longtime Chicago engineer Bilal al-Masri (second from left, middle row), lend a helping hand at the health fair.

Hassan Abdullah was a longtime community leader. He served as the official representative for many years of the Arab League. When he died, a special scholarship fund was established in his name to help other Arab students achieve their career goals.

Members of the Hassan Abdullah Scholarship Fund pose with a check that was donated to help provide scholarships to Palestinian students at Birzeit University north of Ramallah in Palestine. The university now has a special media training center, thanks in a large part to the support of the scholarship fund and the fundraising committee. A similar scholarship has been endowed at the University of Illinois at Chicago in Dr. Abdallah's name by his wife. Pictured here are Kayyad "Edward" Hassan, Dr. Farouk Mustafa, Rashid and Mona Khalidi, the late Dr. Abdallah's wife Constance, Dr. Carmela Armanios-Omary, Hasan El-Khatib, and Riham Barghouti.

Dr. Mustafa is a former member and chairman of the Chicago Arab Advisory Commission. Rashid Khalidi is a professor of Middle Eastern Studies who taught at the University of Chicago and later Columbia University in New York City where he holds the Edward Said Chair. Dr. Khalidi is the author of several books. Armanios-Omary and Barghouti are representatives of Birzeit University. (Photographs courtesy of Constance Abdallah.)

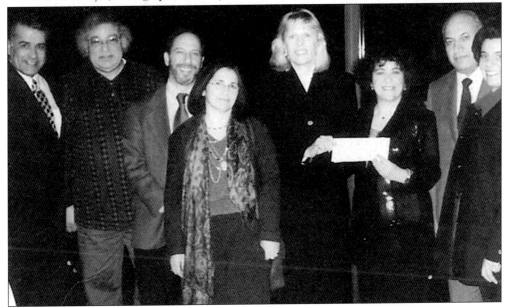

The Ramallah American Federation is one of the nation's largest Arab cultural organizations in the country, linking Palestinians who trace their heritage to the city of Ramallah, a predominantly Christian city located just north of Jerusalem in Palestine. Pictured above from 1976 are children wearing Palestinian flags on their t-shirts preparing to perform for the federation's Chicago conference that year.

Twenty-five years later, a representative of the federation's 43rd Annual Conference presents a certificate to recognize the writing achievements of Lorene Zouzounous, a member of the Radius of Arab Writers Incorporated (RAWI), a guild for Arab writers, authors, poets, and journalists co-founded by Leila Diab and Barbara Nimri Aziz.

Members of the Lifta Association are seen here at a cultural fair in August 2000.

Attorney Omar Najib, a former president of the American Arab Anti-Discrimination Chicago Chapter, poses with Kayyad "Edward" Hassan. Najib is also a former president of the American Arab Anti-Discrimination Committee (ADC) and a civil rights lawyer.

The State of Illinois hosted a special tribute to ethnic women in 1999. Pictured here are members of the Women's Islamic Association for Palestine: Rehan Rashid, Reem Osman, Sima Srouri, former first lady Lura Lynn Ryan, Azza Jammal, Shaista Shaik, and Banan Said.

Also pictured in celebration of ethnic women are, from left, Fatma Abueid, Mrs. Ryan Dalal Adawy, Amna "Anna" Mustafa, and Nareman Sawafta. (Photographs courtesy of the State of Illinois and Governor Ryan.)

BUSINESSES AND ENTREPRENEURS

Arab Americans have been engaged in many businesses from restaurants to stores selling food, novelties, clothing, and other items. There are many Arab stores in Chicagoland, dispersed throughout many diverse communities. Many Arab grocers purchased their stores from Jewish and Italian business owners in the 1940s. And many went into business as a result of the efforts of Fuad Haleem, who worked with Kraml Milk. Fuad and Kraml Milk, according to relatives, provided funding to Arab immigrants to open stores, in exchange for offering only Kraml Milk dairy products. As a result, dozens of small grocery stores were opened and later owned.

Above is the Mediterranean Bakery at 3109 W. 59th Street, taken in 1977.

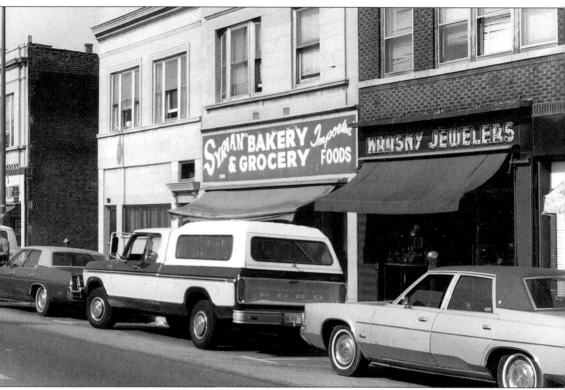

The Syrian Bakery & Grocery store at 5033 S. Ashland (photographed in 1975) was owned by import magnate Ahmad Ziyad. The story of the Ziyad family's immigration and rise in America is typical of the success stories of many Arab families who live in Chicagoland. Ziyad left Palestine in 1961, but could not get a visa to come to America because of the limits on the Middle East. So, he did what many Arabs did, and moved to Brazil. In 1962, he married Judy, of Brazilian ancestry, and they obtained visas to come to the United States in 1963, arriving first in Miami, where their eldest son, Nemer, was born. "My dad came to this country with only $123 in his pocket," Nemer recalls. "When I was born, we lived in a garage in back of someone's house. My dad and mom worked very hard for every penny. Dad would collect old clothes, clean them, repackage them and then sell them to the migrant workers in the Miami area at the time. Most were Jamaican. In 1965, we came to Chicago and he peddled out of his car, working three jobs and selling life insurance. Mom worked, too. And then in 1966, he opened his first store, the Syrian Grocery & Bakery at 5033 S. Ashland Avenue. It was the first Middle Eastern store of its kind in the Midwest."

The company has grown significantly from its beginnings in the trunk of Ahmad's car into a multi-million dollar corporation, providing Middle Eastern and Arabian foods, ingredients, and supplies to 5,600 small mom-and-pop grocery stores much like the Syrian Bakery & Grocery of the 1960s. Today, Ziyad Brothers Importing at 5400 W. 35th Street in Cicero also provides food products and supplies to more than 6,000 mainstream supermarkets across the United States, including Jewel and Dominicks. Their customer base extends across 48 states and six countries and continues to grow.

"My dad loved this country. He was proud to be Palestinian and Arab and was a devout Muslim, and he was also a proud American," Nemer recalls. "We all learned to love this country from our parents and our relatives."

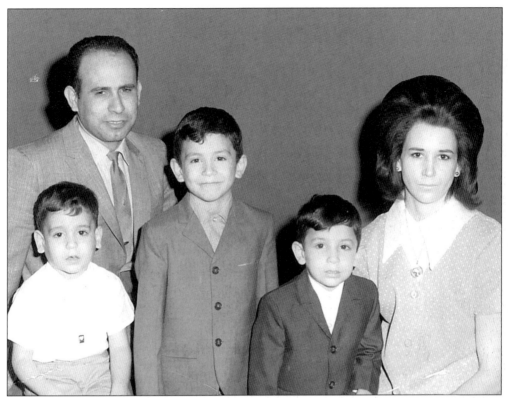

In this 1970 photograph, Ahmad Ziyad, the owner of the Syrian Bakery & Grocery store at 5033 S. Ashland Avenue poses with his children, Nazmy, Nemer, Nasim, and their mother Judy.

From left, Ahmad's brother Ibrahim Ziyad, Ahmad's father Ahmad Ziyad (shared same name), and Ahmad Ziyad are seen here right after opening their business.

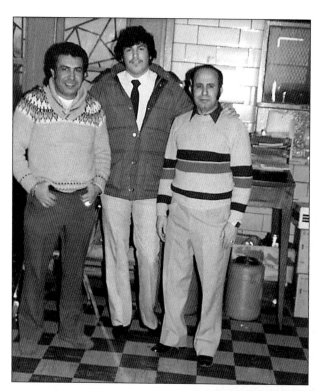

"They made everything from scratch in those days," recalls Nemer Ziyad about his father, Ahmad, grandfather Ahmad, and uncle Ibrahim. "The business was doing well, and they continued to expand in 1968 and 1969 buying a building next door, and in the mid-1970s, they opened a 38,000 square foot wholesale warehouse at 2100 S. Western Avenue."

Pictured at the Western Avenue warehouse, which was now supplying Middle Eastern food stores around Chicago and the country, are Ibrahim Ziyad, Nemer Ziyad, and Nemer's father Ahmad Ziyad.

Ahmad Ziyad (second from left) is pictured here with his three sons, Nassem, Nemer, and Nazmy. Ahmad Ziyad died on May 31, 1996. Nemer and his uncle Ibrahim manage the business. Nemer is the executive vice president of Ziyad Brothers Importing. (Photographs courtesy of the Ziyad Family. The photograph of the Syrian Bakery & Grocery courtesy of the *Middle Eastern Voice* newspaper.)

It wasn't uncommon, despite the perceptions, to have an Arab grocery store like Bawadi Grocery located next to a Synagogue. Pictured above is Lawn Manor Beth Jacob Temple at 6100 S. Kedzie. Today the temple remains, servicing Ethiopian Jews. For many years, especially through the early 1970s, Arabs and Jews lived in the same neighborhoods in Chicago. Eventually, the politics of the 1967 Arab-Israeli war and "white flight" moved the Jewish community into the north suburbs of Skokie and Niles while many Arab Americans moved west to Oak Lawn and Burbank or North to Evanston.

The New Ashland Medical Center managed by Arab and Muslim doctors at 4800 S. Ashland Avenue is pictured here in 1977.

In the early 20th century, there were few restaurants offering Arab or Middle Eastern cuisine. They included the Mecca Restaurant and the Sheharazade Restaurant. Today, there are more than 70 Arab American restaurants. A pioneer in the restaurant business in the 1970s was Steve Adawi, who puts as much effort into decorating with strong Arab and Middle Eastern tenor, as he does in preparing his Arabian dishes. The effort reflects his longing to return to his homeland, Palestine.

"It's the only way I can make myself feel at home," he says, not critical of the courtesies he has received from Americans. His wife is American, and her mother works with him at his newest restaurant, Steve's Shish Kabab House at 3816 W. 63rd Street. His brother Jameil "Jimmy" Adawi operated a Shish Kebab restaurant in Bridgeview for many years.

Born in Jerusalem, Adawi's family is originally from Ramle, an Arab town located 14 miles from the Mediterranean in Palestine. "We had to leave because of the war in 1948. I was only four years old at the time, but I remember my grandfather telling me about the five homes he owned with my uncles and relatives," Adawi remembers. "My father moved us to Latrun after the war near Imwas. He wanted us to stay there because he kept saying the Arabs where going to defeat the Israelis, who were all immigrants from other countries. He kept saying, don't worry, we will be returning to our homes soon." It never happened, though. "We stayed in Latrun for about a year until my father realized we would never go back. We moved to Amman, Jordan. There were a lot of Palestinians there. And then we moved back to Jerusalem and settled near Ramallah and Beitunia."

Adawi left Palestine to find work in Kuwait, and in 1967, he decided to go to the United States where he heard many Arabs where making good money running small businesses. "We were on the plane when the news about the 1967 war broke out," Adawi recalls. "I will never forget that flight."

Adawi said he came to the United States because he wanted to find a good job and earn money to help his family. He flew from Kuwait to New York City, where he stayed a few hours, and then caught a connecting flight to Chicago.

"I had friends in Chicago, but I could hardly speak English. My hand to God, I found a job at a company called Held Floor Machines. I cried every night for a month wanting to go back to my home in Palestine. That is where we were from. I wanted to go back but I couldn't."

"At first, it was very, very rough. But you know, I see that people were better back then than

they are today even though it was tough to make a living, to survive. People would help each other more. The community was closer and willing to help. Today, it's different. It's not racism. We were only a small community when I first came here. Today, there are many more Arabs yet we seem further apart rather than closer. I think we got along better by then."

Adawi found a job at the Salam Restaurant at 83rd and Cottage Grove, owned by the Imam Elijah Mohammad, a leader in the American black Muslim community. Adawi said the restaurant was really owned by Muhammad Ali, the boxing champion and a disciple of the black Muslim movement. Ali (Cassius Clay) had converted to Islam from Christianity and loved Arabian food.

After working as the cook, Adawi opened his own restaurant, the Cleopatra at 51st and Ashland Avenue, next to Hemlock Federal Savings and Loan Bank. "The big problem back then was that no Americans would come into our restaurants. They didn't come to eat our food. Back then, they didn't seem to know us very well so all our clients and customers were Arabs," Adawi remembers. "That made it difficult. But we had a strong community, and my restaurant was one of the first to open there." Ali would often visit his restaurant, preferring the Arabian made dishes.

In 1971, Adawi closed the restaurant as the community shifted south and west to the area of 63rd and Western Avenue. But in 1974, he returned to 51st and Ashland to try again, opening Mr. Steve's Gourmet Restaurant. Ali and others followed, remembering the foods he had prepared at the Salam. "He really loved our food," said Adawi, who still has several pictures of Ali being served Arabian food at his restaurants. Later, Adawi ran a meat/grocery market at 66th and Western, but he returned to the restaurant business to open another Steve's at 2618 W. 63rd Street.

Although Adawi believes the community was closer in the early years, he says American perceptions are more positive today than they were before. "Americans are more educated about us. They know our culture and heritage better. They know about where we came from. They know the real story about Palestine, and they will listen to us when we talk about what has happened. There is still some misunderstanding, and we have a lot more that has to be done, but I think we have made some achievements with the Americans, and it is good for us," Adawi says. "The bottom line is that when you respect other people, other people will respect you. Sometimes we forget that, and we shouldn't."

Carpenter and contractor Mussa Ayyad (far right) helped build many of the commercial strip malls. Mussa is pictured with his brother Ahmed Ayyad (far left) and Yacoub Saleh (center) in this 1975 construction project on north Ashland Avenue.

Na'Shat and his brother Mohammed Ibrahim came to Chicago with their parents in 1984. Born in the village of es-Salt near Amman, Jordan, Na'shat's parents fled from Palestine after the 1948 Arab-Israeli war. In 1991, they opened the Pita Pocket Bakery and Restaurant at 2849 W. 63rd Street and then moved west to 3326 W. 63rd Street. "We love it here. It is a mixed neighborhood of Arabs, Mexicans, Italians, and Greeks, and they all love Arabian foods," said Na'Shat who has a degree in biochemistry from UIC. Na'Shat said that it was always his dream to return to their family home in Palestine, a village called Daniyya near Lydda, now in Israel. "We dream. We work hard. And we live a good life being respectful to everyone. That is how we are."

112

For many years, the Jerusalem Grocery at 9206 W. 159th Street was the only Arab-owned grocery and food store in Orland Park. The bright red sign on the facade of the store screams its name out loud for all to see.

Ribhieh Hussein, a Muslim woman in her late 40s, opened the bakery in 1994, about two decades after immigrating to the area from Palestine. Her children and cousins help manage the store. In addition to the panoramic picture of Jerusalem that hangs above her counter, she also has a picture of the Dome of the Rock and the Old City of Jerusalem painted on the large front window. "There is a very large Arabian community here, and they buy a lot of food and especially bread. I can never make enough bread, and I sell it out as fast as I make it. Even the Americans who have tasted Arabian food come here to buy hummos dip, crack wheat, and even grape leaves. I don't have problems with them because the food is good, and the store is clean." Ribhieh is the symbol of determination, overcoming the odds against her. "It is hard being a woman, but I don't get treated different. We are in the United States, and we women have equal rights. I have equal rights, and I will not let that go," Hussein smiles as she continues to prepare her bread.

The shelves are filled with all kinds of canned Arabian foods, bags of spices, and Arabian food mixes. On the counter are bags of flat pita bread. A dozen in each bag, they sell for only $1 per dozen. Ribhieh makes hundreds of bags of bread each day, and they all sell. She relies on three machines to prepare the bread. A large mixer churns the wet dough until it is plied just to the right texture. She then takes the large, heavy round ball of bread dough, flattens it slightly on another aluminum tray, and slips it into a compressor that presses the dough and breaks the larger ball into 36 smaller balls of dough. A third machine is used to flatten out each ball of dough, and they are placed on trays. She has two other large machines, Blodgett ovens, the kind that you would find in the dozens of Italian pizzerias that dot the Orland Park area.

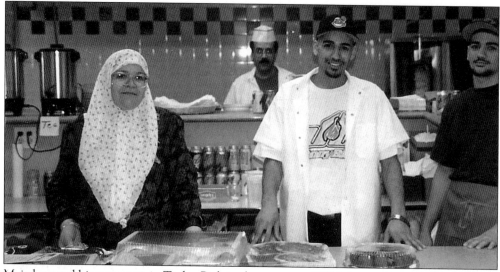

Majed opened his restaurant in Tinley Park in the summer of 2001. It was the second store in the far Southwest suburbs to offer Arabian foods, along with the Jerusalem Grocery. Majed's restaurant was located at 76th Avenue and 159th Street and was doing a healthy business when the author interviewed him in the summer of 2001. "Americans love Arabian food," said Majed (in back), who worked as a cook at several Arabian restaurants before venturing on his own that year. "And Arabian food is a great way for Arabs to meet Americans and Americans to meet Arabs. We both have a love for this country and a love for freedom and a love for our children to grow up healthy, educated, and successful." Unfortunately, September 11, 2001, changed the way many Americans viewed Arab Americans. After the attack, a mob of some 300 people, mostly younger, protested around the Bridgeview Mosque, waving American and confederate flags, chanting "death to the Arabs." Businesses along Harlem Avenue had windows broken by vandals who targeted anyone who looked Arab, including many non-Arabs including Pakistanis, Mexicans, and even Italians. One Italian employee at a music store in Orland Park said that he had to shave his beard and cut his hair because customers thought he was Arab. Majed's restaurant was forced to close.

The United Trust Bank opened on September 7, 2001, to make history as the first majority Arab-owned bank in American history. Owners and businessmen joined with the National Arab American Journalists Association and Arab American newspapers to promote a community-wide celebration. Invitations went out, and the community came in to open accounts at a bank which featured employees who not only spoke Arabic and understood the value of cultural sensitivity.

This is the first picture of the first Arab bank, United Trust Bank, when it opened before the permanent facility was completed months later.

(*left*) Attending the opening reception of the Arab Bank are former Chicago Bulls player Norman Van Leer (third from left), businessman Robert Sweiss (far left), and Bassam Salman, a bank officer (far right). (*right*) Former bank officer Wally Aiyash, who with his brothers Zeze and Rocco own and operate the successful chain of Pazzo's restaurants, helps sign up customers on opening day at the bank.

Brothers Waleed and Malik Ali built MPI Media Group more than 30 years ago, amassing a library of more than 60,000 hours of documentary film and the rights to some of the greatest video recordings in history, including collections of the Beatles, David Bowie, Tom Petty, and Willie Nelson, and rights to films held by the estates of Jackie Gleason, John Wayne, the Rev. Dr. Martin Luther King Jr., and others. They formed MalJack Productions in 1976, operating out

of their house, and in 1978 built a 6,400-square-foot building. They finished school with degrees in business administration. Waleed added a major in communications, while Malik studied finance. Today, MPI is housed in a 42,000-square-foot facility in Orland Park. After his brother's death, Malek joined in founding the Orland Prayer Center in 2004, overcoming the anti-Arab backlash of September 11, 2001. Pictured at right are Orland Prayer Center co-founder Mohammed Krad, Bridgeview Mosque Imam Sheik Jamal Said, and Malek Ali in 2004. (Photograph courtesy Talat Othman.)

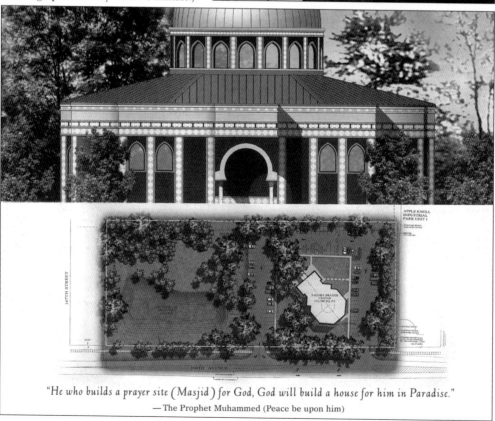

"He who builds a prayer site (Masjid) for God, God will build a house for him in Paradise."
— The Prophet Muhammed (Peace be upon him)

Wafa Hanania joins WVON Morning radio talk show host Cliff Kelley and Iraqi journalist and poet Ihsan Quiraishi at a reception hosted by the National Arab American Journalists Association in April 2001.

NAAJA members join Arab community leaders to support Mike Monseur after he lost his job at the *Chicago Tribune*-owned CLTV cable news station.

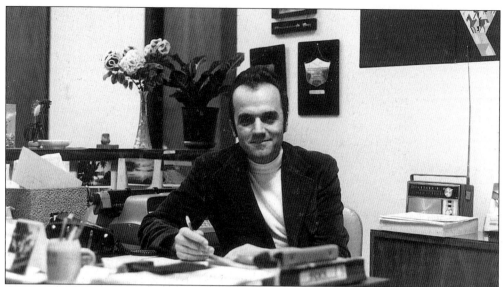

A pioneer of Arab radio programming in the 1970s was the "Middle East Radio Show" hosted by travel agent and Lebanese American activist Tobia Hachem. Hachem's program offered mainly Arabic music, but he was a major sponsor of the *Middle Eastern Voice* newspaper, also advertising on other Arab radio programs including the "Voice of Palestine" radio show.

Yusef Shebli hosts a live-talk radio program called "Inta Fil Howwa" ("You're on the Air"). The program is officially called "Sout al Jaliyya Al Arabiya" ("Voice of the Arab Community") or "the Arabic Radio Program." But it is not your typical station offering music and news. The program on WPNA is considered not only the first live Arab American radio broadcast in this country, but also the liveliest in the city. Every Saturday from 5 to 7 p.m., Shebli sits in front of the microphone and engages callers in sometimes heated, but always interesting, discussions about the Middle East and the Arab community. Salameh Zanayed hosted the program before Shebli for more than 10 years, offering mainly news and information. Shebli took over in January 1985, and in a few months converted it into the first live Arabic talk show in the country. Shebli funds the program himself on WPNA Radio 1490 AM, with some advertising support.

Former NBC correspondent Jim Avila (now with ABC), of Lebanese and Mexican heritage, landed a job in Chicago for WBBM, then joined KNBC in Los Angeles. After winning numerous awards, he was promoted to national correspondent for NBC in January 2000. "We need more Arab journalists, though," Avila said during a journalism reception honoring NBC colleague Hoda Kotbe, an Egyptian American Muslim correspondent, in August 2001. "This profession is the most honored profession in our country. It is the only one mentioned and protected in the Constitution," Avila said. "Our dedication is to be accurate. Fair. And to report issues as they are. That is the most important contribution we can make."

Kawthar Othman (third from left) is the publisher of *al-Offok al-Arabi Newspaper*. Founded in February 1998, it remained one of the few Arabic language newspapers in the region that survived the September 11th aftermath. (There were seven Arab American newspapers prior to that.) Kawthar is one of the only Arab woman professional journalists.

Tom Shaer has worked for 13 years as a sports anchor and reporter for WMAQ-TV (NBC-affiliate). He also hosted a popular morning talk show on WSCR-AM and was morning sports anchor on WBBM-AM, both CBS-owned stations in Chicago. He is an Emmy Award winner and was cited by *Crain's Chicago Business* as one of the city's top broadcasters. Tom became a sports correspondent for the Associated Press in 1977 at the age of 18. He joined AP Radio that same year, then moved to Boston radio station WITS in 1978. In 1983, he came to Chicago as co-host of a nightly sports magazine show, with broadcast legend Jack Brickhouse, on WGN. Before joining ESPN-1000 in September of 2002, the 25-year broadcasting veteran launched Tom Shaer Media, Inc. in May 2000. TSM provides audio and video to web sites, radio, and television production. They are involved in joint marketing projects with The Rosen Group of Chicago. (Photograph courtesy of Tom Shaer.)

Pat Michalski poses with Yusef Marei, the only other Arab American who hosts a live talk radio program in Chicago focused on Arab and Muslim audiences. Marei's popular weekend program, "The Arab Voice," is broadcast every Sunday on WCEV-AM (1450) and keeps Arabs and Muslims aware of events and activities. Each week Marei features a special interview guest.

One of the great writers in Chicago is Musil Shehadeh, who currently writes for the London-based *Palestine Times*. Shehadeh, a story teller, entertainer, and human rights activist, is pictured here playing the accordion at a 1975 picnic of the Arab American Congress for Palestine at Montrose Park.

Award winning poet and Arab Muslim activist Sammer Ghouleh recites one of her many poets at an event in 1999. She serves on the board of the Illinois Spina Bifida Association and has written several poetry books, including *Treasured Misfortunes*. She is the author and founder of *Spirit Magazine*.

Aladdin Elaasar is author of *Silent Victims: The Plight of Arab & Muslim Americans in Post 9/11 America*, published by AuthorHouse. Aladdin is a journalist, educator, poet, short-story writer, public speaker, and cross-cultural and media consultant whose writings have been published in several newspapers in the USA and overseas, in both English and Arabic. He has contributed articles for on-line portals on the Middle East, such as Estart.com and Planetarabia.com. He has produced several programs and documentaries and taught media studies, translation, and creative writing. He has also been a frequent guest as a commentator on Middle Eastern affairs on several local American television and radio networks.

From left, author Ray Hanania joins PAC Board Chairman Qaseem Blan, WMAQ-TV reporter Art Norman, journalist and writer Ali Alarabi, and Chicago Park District Commissioner Rouhy J. Shalabi in 2004. (Photograph courtesy of photojournalist Ali Ido.)

Journalist and writer Mustafa Owaynot is seen here at an Arab American banquet in 1976.

Newspaper publisher and writer Ali Baghdadi is pictured here at a Chicago Arab American banquet in 1976.

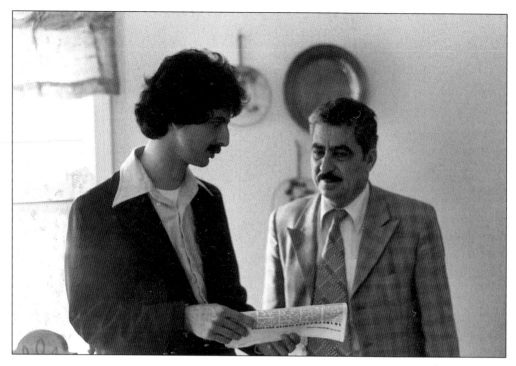

Author Hanania interviews Nazareth Mayor Tewfiq Zayad in 1975 for the *Middle Eastern Voice*. Shown below is part of the front page of a 1976 edition of the newspaper.

The **Middle Eastern Voice**
5450 W. 84th Street
Burbank, Ill., 60459

BULK RATE
U.S. Postage
PAID
CHICAGO, ILL.
PERMIT No. 55

Middle Eastern Voice

"Serving Chicago's Arab-American Community"
Dedicated to the expression of the Arab-American Viewpoint

Vol. II, No. 2 February 1977 **FREE**

Register to Vote

repared for the coming Mayoral
on. The primary election, a
edure that determines the
late for each party, will be held
19. You must be registered, as a
cart, Republican or Independent,
der to vote in the primary by
21. The actual election will be
on June 7. Regardless as to
er you are Democratic,
blican or Independent, you must
gistered by May 9 in order to

e eligible, you must: be a citizen,
U.S. on the day of the election;
years or older (on election date);
reside in your precinct for 30 days
re. You must register if you have
registered before, or if you
ed your address since the last
you registered.
Information will be published in
ext issue.

ew AAUG fficers

Nakib was elected President of
linois Chapter of the Association
rab - American University
uates, Inc., (AAUG) at a special
ral Assembly meeting that was
at the Midland Hotel on January
lthough poor attendance seemed
mper the meeting, only 9 of those
ent were eligible to vote
ociate and student members are
ible), a decision was made by
present to continue with the
ion process.
slates were presented. The
dates were, Slate I: Sam Nakib,
dent; Suheil Nammari, V.P.;
ella Figi, Secretary; and,
im Fakhreddine, Treasurer
I: Mary Al-Azzawi, President;
ella Figi, V.P.; Fadwa Hasan,

900 Attend Fr. John Gale

By Raymond G. Hanania

Over 900 people attended the 28th
Annual Father John's Dinner Dance
on Saturday, January 22 at the
Northlake Hotel (formerly the
O'Hareport Hotel) in Northlake.
Sponsored by Our Lady of Lebanon
Maronite Catholic Church, the
audience of Lebanese, Syrian,
Palestinian and Jordanian Americans
enjoyed a full evening of food,
entertainment and brief speeches.

Five Christian religious leaders from
surrounding Chicago Arab-American
communities were seated at the head
table. They were the Right Reverend
Archimandrite Athanasios Emmert of
St. George Greek Orthodox Church in
Oak Park, Fr. James B. Namie, the
Most Rev. Francis M. Zayeck, Bishop

LORICE PETERS entertains at the well - attended Annual Dinner for Fr. John Naffeh.

colorfully dressed young wome
ceremonially performed an att
"Bedouin Dance", as well org
Middle Eastern Dabka, and a
"dance of Ancient Egypt." The
were choreographed by Nata
well-known oriental dance
entertains weekly on Saturda
Sundays at the Port Said Rest
located at 6245 So. Cicero Ave
Orientale Fantasy Dancers
their talent and are scheduled t
an appearance at the Por
Restaurant on March 5. Reser
are required.)

An excellent Arabic band
Detroit, Michigan pr
livelybackground music fo
Peters, while the Orientale
Dancers entertained to
specially recorded by the Po

Tribune City Hall reporter Thom Shanker (center) participates in one of author Hanania's radio shows, interviewing then mayor Harold Washington.

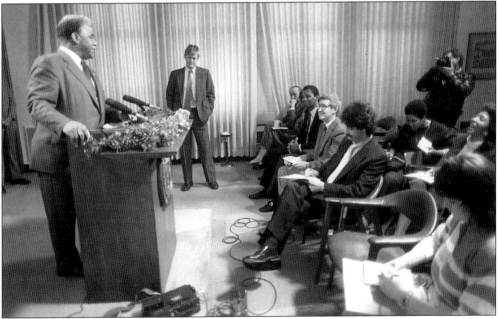

This photograph shows author Hanania as *Sun-Times* City Hall reporter at a press conference held by Mayor Washington. Standing against the back wall is Washington Press Secretary Alton Miller, and on Hanania's right is former WBBM radio reporter Bob Crawford. WGN radio reporter Avis Lavelle is sitting behind Hanania in the picture, taken just before Washington's death. Hanania succeeded Harry Golden Jr. as the *Sun-Times* City Hall reporter; Golden also served as Hanania's mentor.

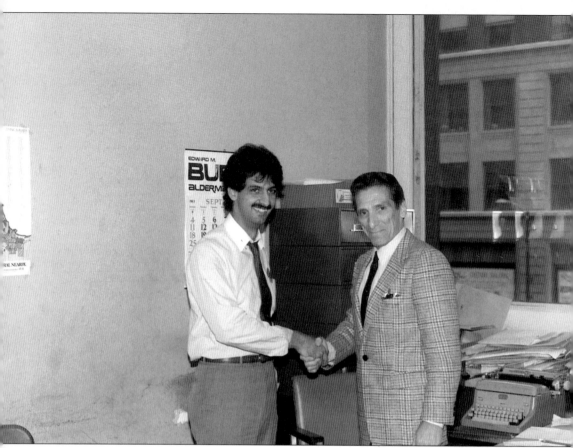

Author Hanania is pictured here when he was working with the *Daily Southtown* at Chicago City Hall with *Sun-Times* reporter and City Hall Dean Harry Golden Jr. Golden and Hanania were very close friends, and on Golden's death in 1989, he left many of his newspaper mementos and souvenirs from his career to Hanania.

ABOUT THE AUTHOR

Ray Hanania is a Middle East peace activist, author, writer, and stand-up comedian. He entered journalism in 1975 as a writer for the University of Illinois student newspaper, the *Illini*. That year, he also published the English-language *Middle Eastern Voice* newspaper hoping to encourage a balanced reporting on the Middle East conflict. In 1976, he began writing features for a weekly tabloid community newspaper called *The Messenger Press*. In 1977, Hanania was hired as an education writer for the then twice-weekly *Southtown Economist Newspaper*. When it became a daily newspaper in March 1978, he was named as the newspaper's City Hall reporter where he launched the popular Grapevine Column, which won a Society of Professional Journalism Lisagor Award in 1985. That year, Hanania was hired to write a celebrity column for the *Chicago Sun-Times* called Page 10, but the *Sun-Times* returned him to City Hall in 1987. He left the *Sun-Times* in 1992 and launched *The Villager Community Newspapers*. He also published *The Video Biz Newspaper* from 1989 through 1996, to provide monthly information on new video releases supplementing a chain of video stores he owned as an investor.

As City Hall reporter, Hanania regularly appeared on WBEZ's groundbreaking Friday morning show at City Hall and was a regular panelist on WMAQ-TV's *City Desk*, WBBM-TV's *Newsmakers*, and on WTTW Channel 11 TV's *Chicago Week in Review*, hosted by Joel Weisman. During his print journalism career, Hanania also hosted a weekly interview show for WLUP-AM/FM radio. In 1982, he joined the staff of WLS radio where he hosted a live

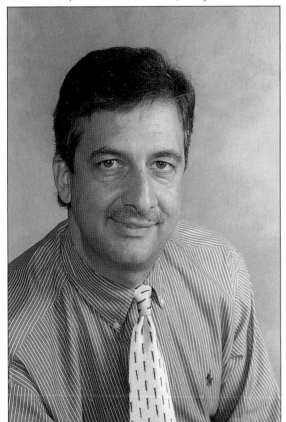

weekend talk show that continued for more than a decade. In 1988, he authored one of the first features on growing up Arab in America, appearing in *Chicago Magazine*. In 1996, Hanania published his first book, *I'm Glad I Look Like a Terrorist: Growing up Arab in America*, a serious and humorous look at growing up Arab in America based on the *Chicago Magazine* feature.

In 1999, Hanania launched his second English-Language newspaper, *The Arab American View* through 2002. After September 11th, 2001, Hanania launched a very successful stand-up comedy career lampooning his experiences growing up Arab in America and his unusual marriage to his wife, Alison, who is Jewish. Hanania has two children, Carolyn and Aaron, and lives in the Southwest suburbs.

Today, Hanania's columns are distributed by Creators Syndicate. He writes a political column for the *Southwest News-Herald* newspaper and the Israeli website http:\ \www.ynet.com.

REFERENCES

Al-Tahir, Abdul Jalil. "The Arab Community in the Chicago Area: The Muslim Palestinian Community." University of Chicago Dissertation, June 1950.

————. "The Arab Community in the Chicago Area, a Comparative Study of the Christian-Syrians and the Muslim Palestinians." University of Chicago Dissertation, June 1952.

Burg, David F. *Chicago's White City of 1893*. Kentucky: University of Kentucky Press, 1976.

Haiek, Joseph. *Arab American Almanac*, 5th Edition. Glendale, CA: News Circle Publishing, 2003.

Hall, Loretta and Bridget K. *Arab American Biography*. Farmington Hills, Michigan: Gale Group, 1999.

Hanania, Ray. "The Historical and Political Development of Chicago's Arab Community." Department of Political Science, University of Illinois at Circle Campus, August 1977.

————. "Notations on the Evolution of the Arab American Media." National Arab American Journalists Association Conference, Chicago, October 1999.

Holbrook, Agnes Sinclair. "Map Notes and Comments." *Hull-House Maps and Papers*. NY: Thomas Y. Crowell, 1895.

Hur, Ben. "Arabs at Chicago." *Western Horseman Magazine* (1950).

Immigrants' Protective League. Cases Current in 1935. Adena Miller Rich Papers, folder 65, Special Collections, University Library, University of Illinois at Chicago.

Lait, Jack and Lee Mortimer. *Chicago Confidential*. NY: Crown Publishers, 1950.

Larson, Eric. *The Devil in the White City*. NY: Vintage Books, 2003.

"Settlers in the City Wilderness." *The Atlantic Monthly*, 127 (January 1896): 119–23.

Suleiman, Michael. *Arabs in America: Building a New Future*. Philadelphia: Temple University Press: 1999.

"Syrians in the United States." *The Survey Journal* 26, No. 14. July 1, 1911: 492.

Tables Showing Arrivals of Alien Passengers and Immigrants in the U.S. from 1820 to 1888. U. S. Treasury Department.

The Arab American View newspaper, archives, 1999–2002.

The Middle Eastern Voice newspaper, archives, 1976–1977.

Watson, Elizabeth C. "Home Work in the Tenements." *The Survey* 25 (February 4, 1911): 772–781.

World's Columbian Exposition Library, Paul V. Galvin Library, IIT, 1999.

Zaghel, Ali. "Changing Patterns of Identification Among Arab-Americans: Palestinian Ramallites and the Christian Syrian-Lebanese." Northwestern University, August 1976.